IMAGES
of America

LAFOURCHE PARISH

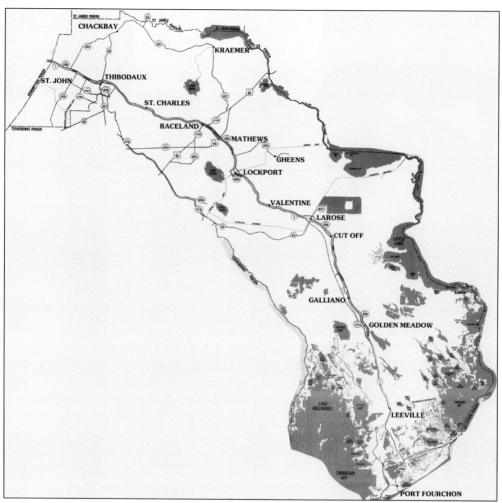

Lafourche Parish is located in southeast Louisiana and is bordered by the Gulf of Mexico to its south, Terrebonne Parish to its west, Assumption Parish to its northwest, St. John and St. James Parishes to its north, and St. Charles and Jefferson Parishes to its east. (Courtesy of Lafourche Parish Tourist Commission.)

ON THE COVER: Members of the congregation of St. Charles Borromeo Catholic Church cross a rope-pulled ferry to attend services around 1914. The location of the church on the east bank of Bayou Lafourche required members from the west bank to cross by ferry. The ferry served the parishioners until it was replaced by a pontoon bridge in 1932 and, later, by a one-lane metal bridge in 1949. The ferryman was Philip Babin, who lived in the small house. (Courtesy of Phyllis Toups Robichaux.)

IMAGES
of America

LAFOURCHE PARISH

Clifton P. Theriot

ARCADIA
PUBLISHING

Published by Arcadia Publishing
Charleston, South Carolina

Printed in the United States of America

Library of Congress Control Number: 2014940825

For all general information, please contact Arcadia Publishing:
Telephone 843-853-2070
Fax 843-853-0044
E-mail sales@arcadiapublishing.com
For customer service and orders:
Toll-Free 1-888-313-2665

Visit us on the Internet at www.arcadiapublishing.com

This book is dedicated to my beloved grandmother Lorena Plaisance Dufrene (1921–1997), pictured at left, who inspired my love and interest in history, and to my dear friend Doris Mae Ledet (1929–2012), pictured at right, a fellow historian and genealogist whose encouragement and assistance in preserving local history was greatly appreciated.

CONTENTS

ACKNOWLEDGMENTS

Several people have helped to make this book become a reality. A sincere thanks and a debt of gratitude go to Sarah Simms, whose advice, encouragement, and assistance were invaluable. Thanks go to Hayley Johnson and Goldie Legendre for their assistance with editing the text for the book. William Charron was instrumental with technical advice and assistance. Thanks go to Emilie Pitre for helping with the daily operations of the archives, freeing up time for me to work on this publication.

Unless otherwise credited, all images in the book are courtesy of the Archives and Special Collections Department at Nicholls State University. Several collections housed in the archives were invaluable in compiling this pictorial history, including the Doris Mae Ledet Collection, the Meyer Family Collection, the Lafourche Heritage '76 Collection, the Historic Thibodaux Collection, the Historic Lafourche Parish Collection, and the William Littlejohn Martin Collection. Other collections utilized were the Coignet Family Collection, the St. John's Episcopal Church Collection, the J. Paul Leslie Photograph Collection, the Wilson A. Petit Collection, the Robert Ruffin Barrow Collection, the James A. Legendre Collection, the Lafourche Heritage Society Collection, the St. Joseph Hospital Collection, the Maude Billiu Collection, the Lee Martin Collection, the J. Wilson Lepine Papers, the Wayne P. Oncale Collection, and the J.L. Basset Collection.

This book was also made possible by several individuals who loaned their treasured photographs and/or assisted with finding historical facts. Those individuals include Kevin Allemand of the Archives for the Catholic Diocese of Houma-Thibodaux, Paul Chiquet of the South Lafourche Public Library, Martin L. Cortez, Brad France, Dee Dee Gaubert and the Bayou Lafourche Folklife and Heritage Museum, Evert Halbach, J. Paul Leslie, Wayland Marcombe, Billy Pitre, Louella Picciola Pitre, Patrick Pitre, Robert M. Pugh, Anke Tonn, Philip J. Toups, and Phyllis Toups Robichaux.

A special thanks goes to my mother, Sylvia D. Theriot, and my family for their continued encouragement. Also, thanks are extended to Dr. Christopher E. Cenac Sr., a friend and fellow historian, for his support.

INTRODUCTION

Life in Lafourche Parish has been centered along Bayou Lafourche for over two centuries. Because it branches off of the Mississippi River forming a fork at Donaldsonville, the bayou was named Lafourche, which is French for "the fork." Bayou Lafourche, which has served as a lifeline for the parish since its inception, is linked to settlement patterns, community self-sufficiency, transportation, economy, and growth.

The area that today comprises Lafourche Parish was traversed by white men during the period of early European exploration and colonization and encompassed the entire region along the bayou from the Mississippi River to the Gulf of Mexico, including the present-day parishes of Ascension, Assumption, Lafourche, and Terrebonne. The European explorers named the region Lafourche des Chetimachas after the Native American tribe they found living in the area. The parish was originally inhabited by Native Americans from the Chitimacha, Washa (Ouacha), and Chawasha (Chaouacha) tribes. During colonization, French, Spanish, Acadian, Canary Islanders (Isleños), German, and Canadian pioneers who had initially settled in New Orleans or along the Mississippi River migrated to the region. The predominant culture and language during the parish's early years was French, still evident today within the parish's Acadian/Cajun population.

The effect of the Roman Catholicism brought to Louisiana by the early settlers during the colonial period can be seen in the governmental divisions, or districts, which were based on Roman Catholic ecclesiastical parishes. After the Louisiana Purchase in 1803, the Territory of Orleans, the present state of Louisiana, was divided into counties, including the County of Lafourche. This county included present-day Assumption Parish, with Napoleonville briefly serving as the county seat. In 1807, Lafourche Interior Parish, encompassing present-day Lafourche and Terrebonne Parishes, became one of 19 civil parishes created by the territorial legislature. Thibodaux was chosen as the seat of government for the new parish. Terrebonne Parish was established in 1822 from the southern portion of the old Lafourche Interior Parish.

Life along the bayou was both rewarding and difficult. When the Louisiana delta formed, high ground or ridges resulted along the waterways from yearly floods. These ridges gently sloped away from the bayous and rivers toward the swamps. Thus, when colonization began, settlers established their farms and constructed their homes along the fertile ridges. Since the bayou and waterways were the main source of transportation, all property fronted the bayou. The French arpent, which is 192 feet, or five-sixths of an acre, was the common form of measurement. Most properties measured only a few arpents wide, so that every home would have access to the bayou and could easily maintain its own levee. Later, roadways were erected along the bayous. This linear pattern of settlement along the approximately 100 miles of Bayou Lafourche formed what many refer to as the "Longest Street in the World." After 1803, these small farms were joined to form large sugar-producing plantations. These plantations required a substantial labor force, which introduced slavery to the region.

The communities of Lafourche are centered along the parish's bayou and numerous other waterways due to the central role these waterways played in transportation around the area. There are three incorporated municipalities in Lafourche parish—Thibodaux (1830), Lockport (1899), and Golden Meadow (1950). The parish seat of Thibodaux was named for Henry Schuyler Thibodaux, whose property was divided to form town lots. The town, established at the historic juncture of Bayou Lafourche and Bayou Terrebonne, was incorporated as Thibodauxville in 1830 and changed to Thibodeaux eight years later. The name was changed to the present spelling in 1918. The town of Lockport, originally known as Longueville, was established in 1835 in the central portion of the parish. Lockport was named after locks that were built at the juncture of Bayou Lafourche and the Barataria and Lafourche Canal in 1850. Golden Meadow was established in southern Lafourche Parish in the 1830s and later became a place of refuge for settlers displaced from coastal settlements due to hurricanes.

The force that created the fertile ridges along the bayous was also the same force that would threaten farmers and plantation owners each spring. Levees were erected along the bayou's edge to protect homes and properties from yearly flooding. Crevasses, or breaks in the levees, were a constant problem. The last break in the levee along Bayou Lafourche occurred in 1903 just above Thibodaux. This break caused residents and local politicians to petition the state government to erect a dam at the bayou's source at the Mississippi River at Donaldsonville. After the damming of the bayou, the levees along the bayou were removed. Many years later, pumps were installed to reintroduce freshwater into the bayou from the Mississippi River. An unanticipated consequence of the dam was coastal erosion along the southern tip of the parish, which continues to be a major concern to residents and businesses.

Today, the use of the bayous and land within the parish has only slightly changed to reflect their modern roles. The southern portion of Bayou Lafourche still serves as a central artery for boat traffic to and from the gulf. The upper and central portions of the parish are still farmed in sugarcane, while the lower portion of the parish supports the fishing and seafood industry. In the 1930s, the discovery of oil and gas changed the economy in southern Lafourche from fishing and seafood to that of shipbuilding and other oil-related jobs.

The motto of Lafourche Parish is "Feeding and Fueling America." Two of the largest industries in Lafourche Parish are agriculture and oil and gas. The agriculture industry in Lafourche Parish consists of crops ranging from citrus to sugarcane, beef, and seafood. The oil and gas industry is supported by the Port of Fourchon and produces roughly 18 percent of the country's entire oil supply.

Lafourche Parish is a diverse and culturally rich parish that has grown and prospered since its founding. Many of the residents of Lafourche Parish today can trace their ancestry back to the early settlers that colonized the area, giving Lafourche a strong sense of community that is distinctive to the area. The ability of the people of Lafourche to forge a prosperous community in often adverse conditions and continue to adapt and grow illustrates the self-sufficient and resilient nature that lies at the heart of Lafourche Parish.

One

North Lafourche

St. John, Chackbay, and Kraemer-Bayou Boeuf

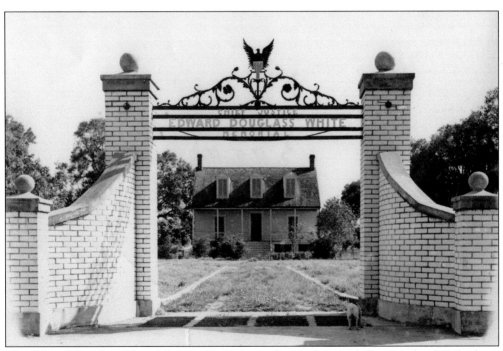

The Edward Douglas White Historic Site is located near the parish line north of Thibodaux. The home was constructed sometime between the late 18th and early 19th centuries. The home, which is a Creole-style raised cottage, was the residence of Gov. Edward Douglas White and the birthplace of his son, also named Edward Douglas White, who served as chief justice of the US Supreme Court from 1910 to 1921.

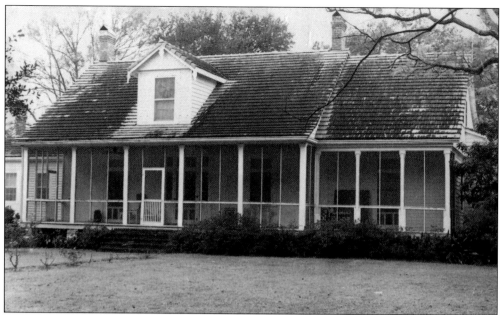

This 19th-century home located on White Plantation is attributed to Thomas Beary, a native of New York who came to Louisiana as a contractor in the 1870s with his brother James. Beary was hired in 1889 to manage the Lafourche Sugar Refinery, which was partly owned by Justice White. In addition to White Plantation, Beary also managed his own neighboring Welcome Plantation. James Beary, who owned Artredge Plantation, was elected sheriff of Lafourche Parish in 1894.

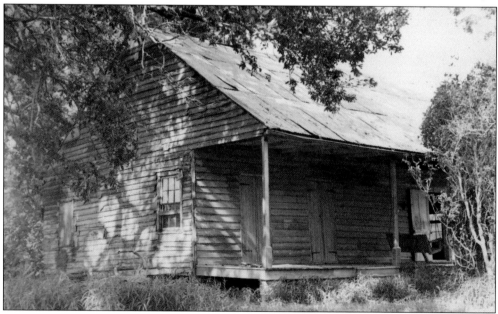

The Jean Charles Germain Bergeron House is one of the oldest surviving Acadian homes in Louisiana. Built in the early 1800s by Acadians who settled here from Nova Scotia, the structure features a Norman-style truss roof, *bousillage-entre-poteaux* walls (mud between posts), and hand-split cypress construction. Originally located on the northeastern bank of Bayou Lafourche, the home was moved to the Rural Life Museum in Baton Rouge in 2005.

The community of St. John, north of Thibodaux, is named for the St. John the Evangelist Catholic Church. A small school and chapel were established at the site in 1876, but it was not established as a church parish until 1919. The church congregation funded the construction of a bridge over the bayou in front of the church and operated it for a fee in 1922. The present church was constructed in 1930 and later enlarged in 1955.

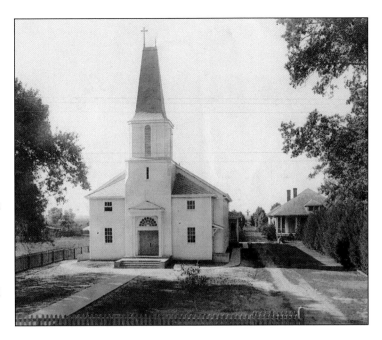

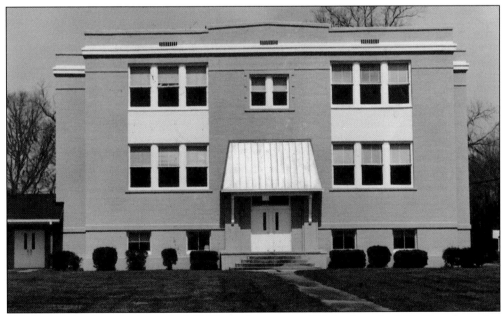

L.T. High School was built on the L.T. Plantation, north of Thibodaux, in 1920. The plantation was named for Leufroy Trosclair. This was a consolidated school that combined classes from Angelloz, St. Anna, Enterprise, and Upper Choupic schools. The school offered 10 grades until the 1934–1935 school year, when it held its first graduation. The last graduation from the L.T. School was in 1948, after which it began to operate as an elementary school, finally closing in 1966.

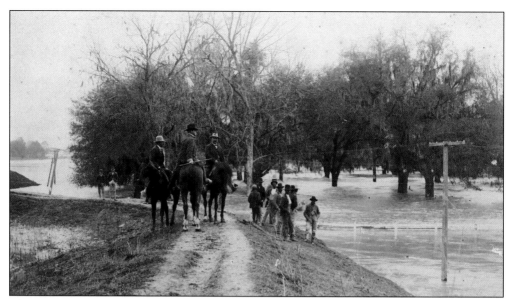

The Waverly crevasse, or break in the levee, occurred in March 1903 in front of the Waverly Plantation, about three miles north of Thibodaux. The flooding inundated Waverly and the surrounding plantations, destroying the sugarcane crops with five to six feet of water. To prevent future flooding or levee breaks, an earthen dam was erected at Donaldsonville in 1904, cutting off the bayou from the Mississippi River. Judge William E. Howell, the owner of Waverly, is pictured above on the center horse. The Howells eventually sold the plantation and mill, pictured below, and moved to Thibodaux.

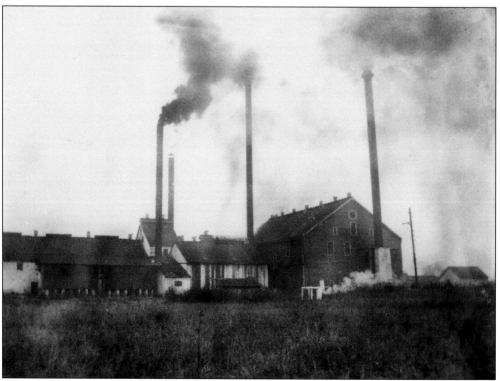

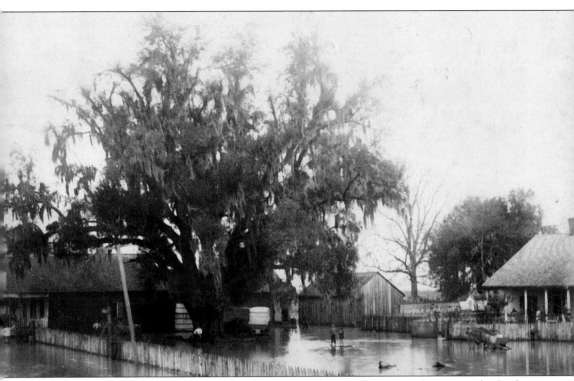

This scene was taken in 1903 during the Waverly crevasse at what is now known as the Brule Guillot Road. Because of the relatively high elevation of this location, it did not sustain the severe flooding that the Waverly Plantation experienced. The building to the extreme left was the first mercantile store of Jules L. Basset, who established his business in 1882. Basset also operated two peddling wagons, which sold goods to homes along the bayou. Both the store and the house were rented from the Mire family. Basset would later build a new store and home a short distance up the bayou. The man seated at the foot of the oak tree is Raoul Basset, son of Jules. Two of Jules's other children, Paul and Yvonne, are also standing in the yard. Note the peddling wagons parked behind the tree.

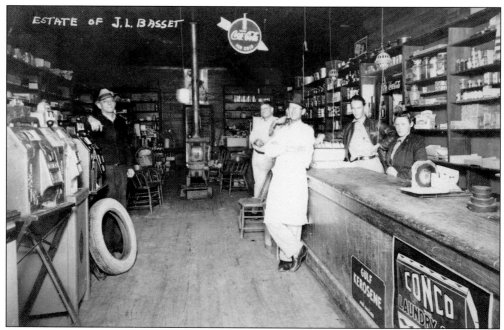

This is an interior scene of the second Jules Basset store taken about 1936. From left to right are Paul Basset, Mickey Gaiennie, Sidney Himel, Billy Chiasson, and Mary Anne Guillot. Note the slot machines to the left of the photograph. The metal balls hanging above the counter hold string that was used to tie packages.

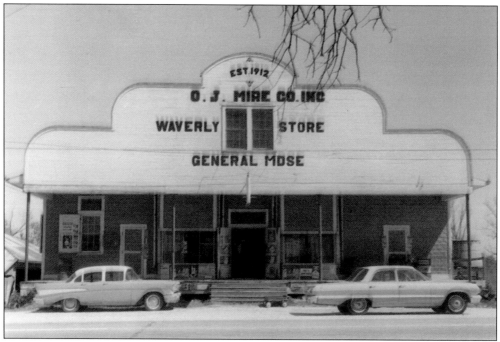

The Oscar J. Mire store was established in 1912 across from the Brule Guillot Road, north of Thibodaux. It was one of the largest country stores that sold general merchandise in the area and remained in operation for many years.

Laurel Grove Plantation was owned by Drauzin Triche until his death in 1875. The plantation was then acquired in partnership with L.A. Trosclair and Eugene G. Robichaux, who operated it for 33 years. In 1946, Caldwell Sugars Cooperative was formed, and it operated the sugar mill until it closed in 2002. The home seen above no longer exists. The derrick seen below, erected on Laurel Grove in 1899, was used to unload sugarcane from barges into boxcars that would then be brought to the mill by rail. Note that the roadway is located on top of the levee.

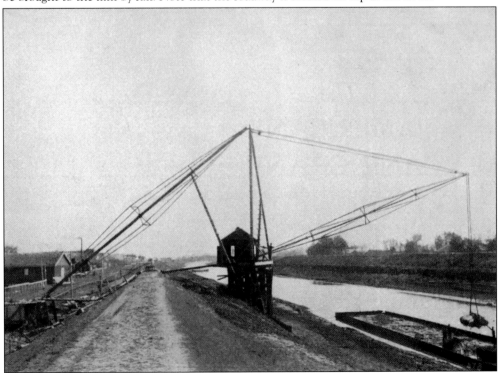

Greenwood Plantation was established in the 1830s and had several owners until 1884, when it was purchased by Ernest Roger, who rebuilt and modernized the sugar mill in 1890. Along with his sons, he ran the plantation until his death in 1920. The plantation was later owned by a bank, which formed the Standard Sugars Company. In 1931, Realty Operators, Inc., was formed, consisting of the Greenwood Factory, and Greenwood, St. Rose, Braud, Abby, and Orange Grove Plantations. In 1948, the name was changed to Southdown Sugars, Inc. (Courtesy of Robert M. Pugh.)

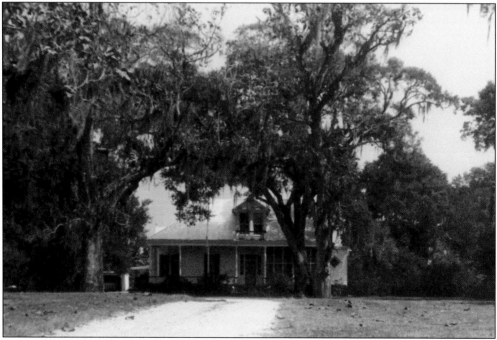

The Home Cottage Plantation is located on the east bank of Bayou Lafourche, a short distance from Thibodaux. It has been associated with the Eugene G. Robichaux, Thomas H. Roger, and LaGarde families.

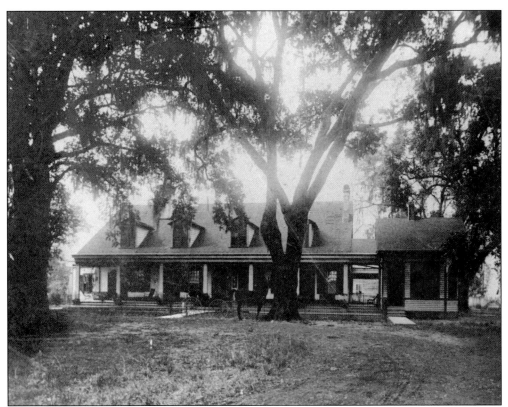

Leighton Plantation was owned and operated from 1842 to 1854 by the first Episcopal Bishop of Louisiana, Leonidas Polk. Later owners were John Williams, Cleophas LaGarde, and Dr. Abel Price. The home pictured above burned in the early 1900s, but the sugar mill is still in operation. Now known as Lafourche Sugars, it is one of only two operating sugar mills in Lafourche Parish.

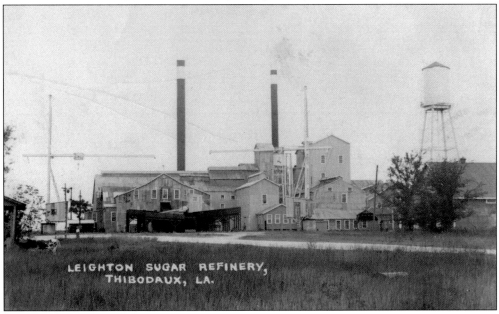

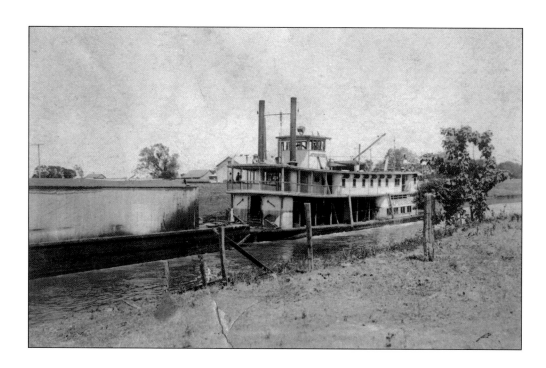

The steamer *Lafourche* was one of three known to use the name Lafourche and was owned by the Barker Barge Line of Lockport. Before the dam was put in the bayou at Donaldsonville, steamboats regularly transported freight and people between New Orleans and the Lafourche district. Afterwards, boats had to travel by way of man-made canals and other bayous to get to New Orleans. Many of the boats made regular trips two or three times a week. The photograph below was taken near the Jackson Street Bridge in Thibodaux and shows a small paddle wheeler and a large dredge boat in the background.

The first chapel in Chackbay was constructed in 1873. It would serve the surrounding communities of Chackbay and Choupic as a mission of St. Joseph in Thibodaux. The church parish of Our Lady of Prompt Succor was established in 1892. Here, a procession of parishioners leaves the old church to lay the cornerstone of the new one in 1951. (Courtesy of Wayland Marcombe.)

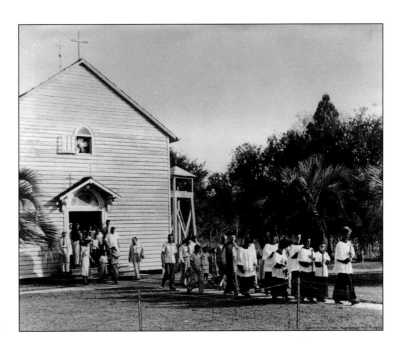

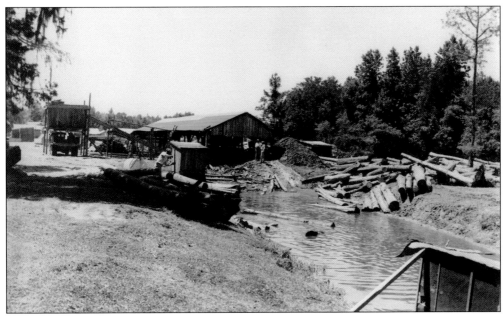

There were several sawmills located throughout the parish in the late 1800s and early 1900s. This sawmill was located in the community of Choupic, near Chackbay at what is now Sawmill Road. The mill was built, owned, and operated by Lawrence Ordoyne. Trees cut locally were attached together and floated down a canal to the mill. The mill also cut timber brought in by truck from Labadieville and Napoleonville. (Courtesy of Evert Halbach.)

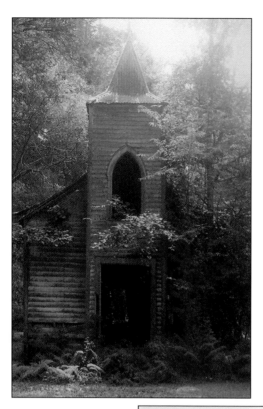

The property on which the Little Zion Baptist Church in Chackbay stood was purchased in 1882. The church was eventually incorporated in 1891. It was sold in 1907 to the congregation of St. Luke's Baptist Church of Chackbay. Use of the church was discontinued in the mid-1900s. The church stood abandoned and dilapidated for many years, finally collapsing in 2011. The cemetery is located behind the church site.

Cortez Grocery Store was located in Bayou Boeuf and was owned and operated by Alcide A. Cortez. His wife, Edna Robichaux Cortez, was a schoolteacher in the area. The store was located in front of the Cortez home and sold homemade ice cream and snowballs as well as groceries. It was opened in 1927 and remained in operation until Cortez's death in 1962. (Courtesy of Martin L. Cortez.)

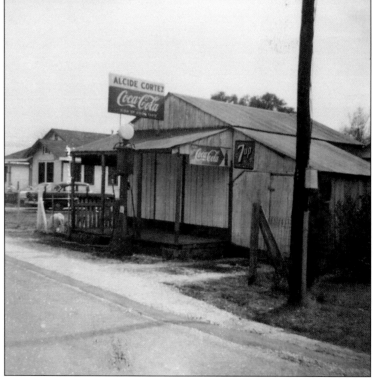

St. Lawrence the Martyr Catholic Church is located in Bayou Boeuf, also referred to as Kraemer. It was a mission of Our Lady of Prompt Succor in Chackbay. Several church buildings were constructed over the years, all destroyed by natural disasters. This frame church served the congregation from 1928 until 1962, when the present church was built and officially dedicated as a parish.

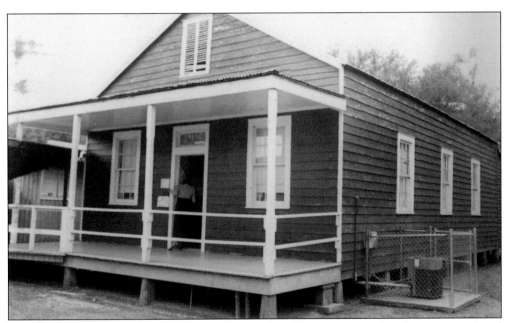

The "Little Red School House" in Bayou Boeuf is the oldest one-room schoolhouse in continual use in Louisiana. The school is the only remaining one of five one-room schools built around the parish in 1904. The elementary school was originally located a short distance away, near the Kraemer Post Office. In 1951, the school was placed on a barge and moved across the bayou to its present location. The school celebrated its centennial in 2004.

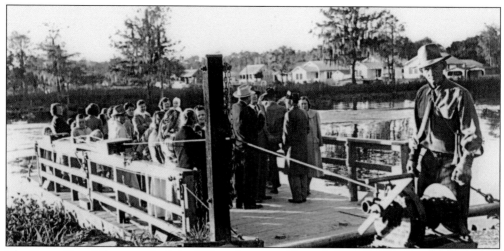

The Bayou Boeuf Ferry was built in 1951 and was used by pedestrians and light vehicles. It was a cable-pulled ferry operated by Augustin Rome. The ferry was replaced by a pontoon bridge in 1958 and then by a drawbridge in 1977. Sources indicate that the pontoon was originally located in Larose. (Courtesy of Martin L. Cortez.)

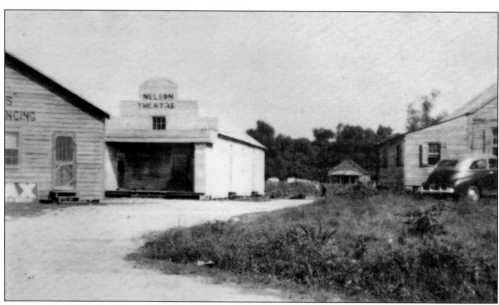

Next to the bridge in Bayou Boeuf are Nelson's Theatre, the Constant Store, and a barroom and dance hall. Nelson's Theatre was built in the 1930s using wood from an old store and closed after Hurricane Betsy in 1965. John D. Constant opened the Constant Store, where groceries were brought in by boat and unloaded on rails that led to the store. Located nearby was a group of three small buildings called the Constant Tourist Courts, which was used by seasonal hunters. (Courtesy of Martin L. Cortez.)

Two

North Lafourche
Thibodaux and Lafourche Crossing

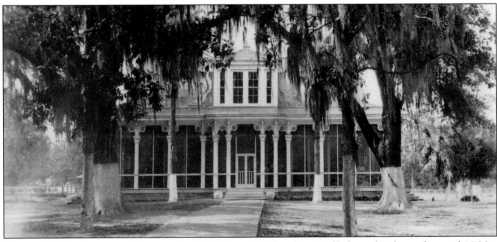

Originally built as a residence, the Knights of Columbus Hall dates back to the mid-1800s. Through the years, the property was owned by the Mills, Nelson, Donelson, and Judge Taylor Beattie families. The home served as Thibodaux's first country club in the 1920s and, in 1930, was purchased by the Knights of Columbus organization. The Lafourche Heritage Society, formed by local preservationists, tried to save the building in 1976. Despite those efforts, the building was torn down the same year.

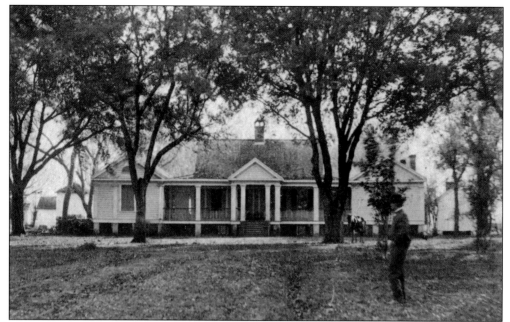

Ridgefield Plantation was the home and plantation of George Seth Guion. The original home dated to the 1830s and was located just north of the town of Thibodaux. The house was later owned by Guion's daughter and her husband, Francis T. Nicholls, who was a Civil War general, former governor of Louisiana, and chief justice of the Louisiana Supreme Court. The original home burned in 1940 and was replaced by an exact replica. (Courtesy of Robert M. Pugh.)

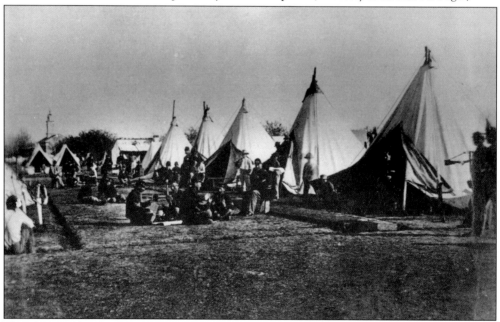

This photograph was taken in 1863, during the Civil War, on the front lawn of Ridgefield Plantation. It was used as a campsite by both the 159th New York Volunteers and the 13th Connecticut Volunteers and was called Camp Hubbard. Note the steeple of St. John's Episcopal Church in the background. (Courtesy Hagley Museum and Library, Wilmington, Delaware.)

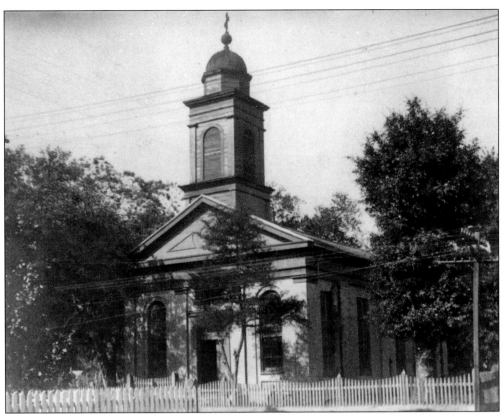

Constructed in 1844, St. John's Episcopal Church is the oldest Episcopal church building west of the Mississippi River. The church and cemetery, located on land that was once part of Ridgefield Plantation, was donated by George Seth Guion. The church served as the first home of the Episcopal Diocese of Louisiana, under the leadership of Bishop Leonidas Polk. The original front portico was enclosed and redesigned in the 1850s by architect Henry Howard, and a choir gallery and bell tower were also added at that time. The photograph of the St. John's rectory was taken around 1911. The children on the porch are Maurice and Helen Mackenzie, children of Rev. Archibald Mackenzie, the rector from 1911 to 1926. The rectory was built in 1884 and remained in use until it was replaced in 1966.

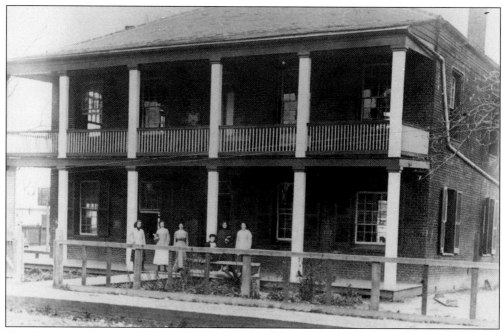

The Guion Academy was the first public school in Thibodaux. It was located on the corner of Jackson and West Tenth Streets on property donated by George Seth Guion. The school opened in 1849 with three faculty members. In 1909, the school was declared the official public high school of the parish, and its first graduates were Florence Simoneaux and Lucy Leblanc. Pictured above in a 1912 photograph are, from left to right, Evangeline Simoneaud, Orena Rudd, Gertrude Peltier, Hattie Plaisance, Leah Thibodeaux, and Velma Williams. Pictured below is the science classroom in 1912, showing Willie Lagarde (leaning over desk), Tom Lagarde (facing right in center), Henry Leblanc, and Fernand Gouaux, on the right.

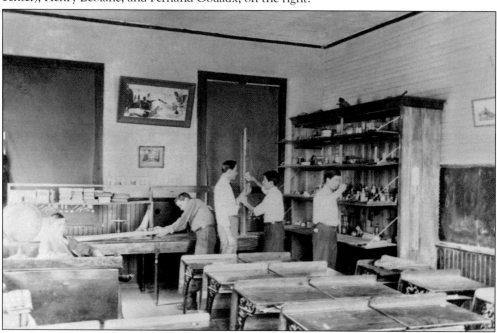

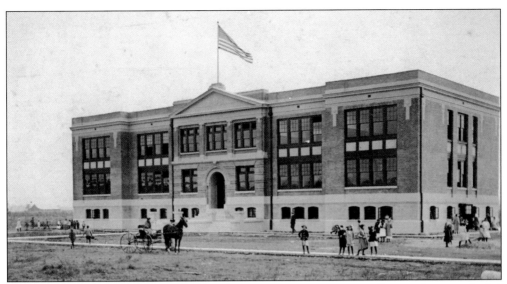

By 1911, the old Guion Academy could no longer support a growing enrollment. A tax was levied and funds were raised for the building of a new high school. In 1912, Thibodaux High School was erected on East Seventh Street. The continued enrollment soon outgrew the facilities, and another building was constructed across the street in 1935 that housed only high school students.

The Corporation School was located on the corner of East Ninth and Narrow Streets. This school was established in the early 1900s for black students during segregation. It consisted of five rooms and held grades one through seven. The first high school for black students was established in the early 1940s and was named for an early black educator, Cordelia Mathews Washington.

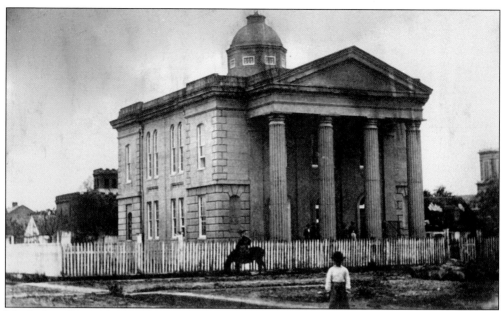

The Lafourche Parish Courthouse, pictured above, was designed by noted architect Henry Howard of New Orleans. The building was constructed around 1860 on land that had been donated by Henry Schuyler Thibodaux, the founder of the town. Two earlier structures, built in 1818 and 1846, were located on the same site. The original front entrance faced Bayou Lafourche. A matching portico with fluted Doric columns as well as several wings was added to the building in subsequent years, which can be seen in the photograph below. The original front entrance was replaced with a wing, leaving only the Green Street entrance. The building reflects several architectural styles, including Classical, Beaux-Arts, and Neo-Baroque. The building is one of the few antebellum courthouses in Louisiana still in use. The courthouse was listed in the National Register of Historic Places in 1979.

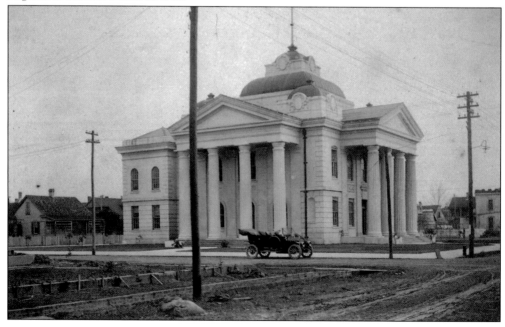

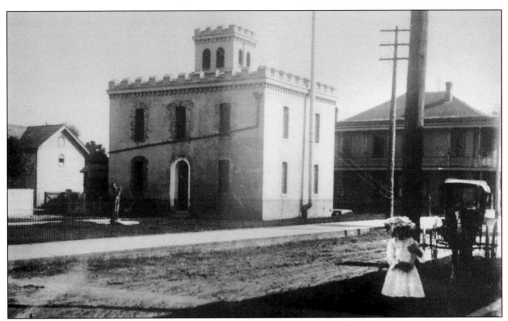

The original Lafourche Parish Jail is located across the street from the courthouse, at the corner of Third and Green Streets. The jail was designed by architect Henry Howard and was constructed shortly before the courthouse, in 1859. The original style of the building was similar to that of the Old State Capitol in Baton Rouge. It was remodeled in the Art Deco style in the mid-1900s. The building is now part of the clerk of court offices.

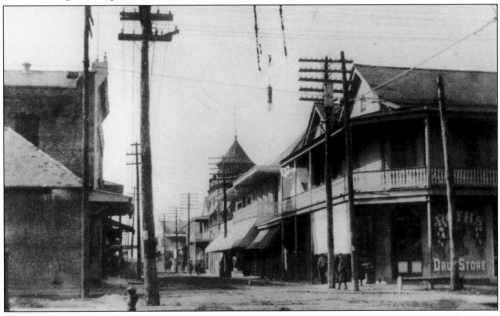

The Roth Drugstore Building is located on the corner of Main and Green Streets, across from the courthouse. The drugstore was established by Eugene N. Roth in the late 1870s. The drugstore was on the first floor, and the second floor was used as the offices and laboratory of Dr. Thomas Stark. A third floor was later added to the building but was subsequently removed. In addition to serving as a drugstore, the building served as a brewery and is now a restaurant.

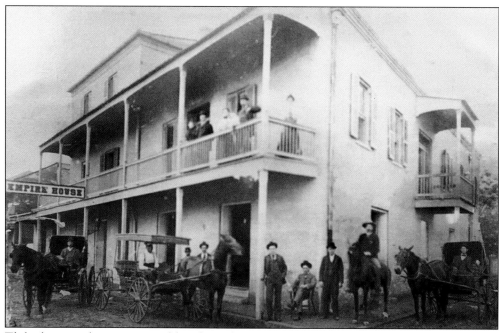

Thibodaux was home to several hotels in the 1800s and early 1900s. The two hotels pictured here were located on Green Street. The Empire House Hotel was on the corner of West First and Green Streets, and Frost's Hotel and barroom was on the corner of West Second and Green Streets. The Frost Hotel, owned by James A. Frost, was originally built as the courthouse and, until about 1859, occupied the site where the current courthouse stands. At that time, the building was sold and moved across the street. The building was torn down in the 1930s.

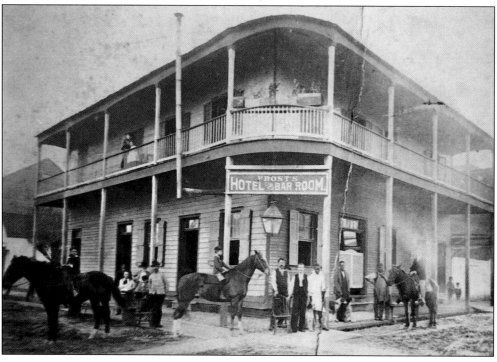

Thibodaux City Hall was constructed in 1886 facing Green Street at the corner of West Fourth Street. The building was equipped with a Seth Thomas clock and bell that could be heard throughout town. A new city hall was opened in 1949 across from the courthouse on West Second Street. The original building was demolished in 1963. The bell has been preserved and is on display at the Warren J. Harang Civic Center.

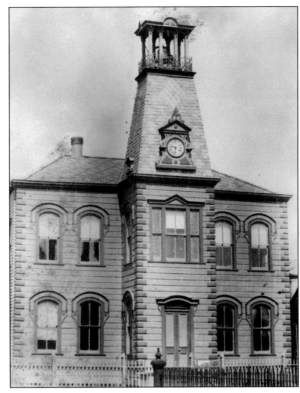

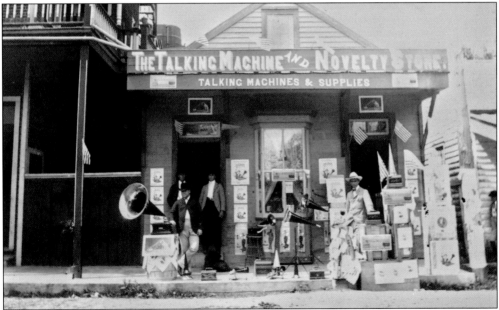

The Talking Machine and Novelty Store was operated by Alfred Malhiot. The building is located on Fourth Street near St. Philip Street. This 1904 scene shows phonographs, or "talking machines," as well as other devices that could play sound recordings. The flags may be Fourth of July decorations. The two-story building on the left was owned by John B. Taylor and housed the offices of the *Lafourche Comet* newspaper.

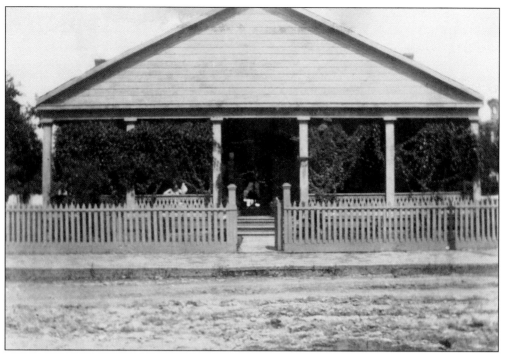

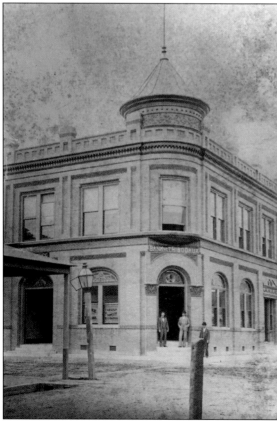

This building was constructed in 1836 as a branch of Union Bank of Louisiana. It was located on Jackson Street between West Fourth and Fifth Streets and was used as a bank until 1852. After that time, it was converted into a private residence, and it later became known as the Marquette Building, for the Edmond Marquette family, who purchased the structure about 1905. In the early 1960s, the building was used as an auto parts store.

The Bank of Thibodaux opened for business in 1891, with Eugene Robichaux as president and Charles Shaver as cashier. The building is located on the corner of West Third and St. Louis Streets. The original stained-glass transoms over the first-floor windows can be seen in the photograph. The doorway on the left was for the post office. The bank, which closed in 1926, was reopened as Lafourche National Bank in 1929.

The Bank of Lafourche was established in 1897 on Green Street, across from the parish courthouse. The front of the building, which still exists, is made of marble. A.J. Braud served as the bank's president. This building later became the Citizens Bank until a new bank building opened on West Second Street in 1962.

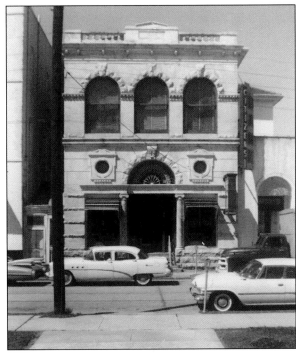

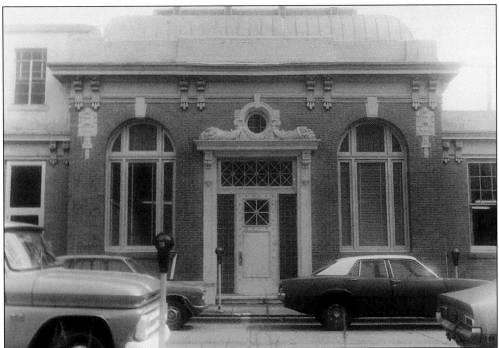

The Citizens Bank of Lafourche was organized in 1910. Eugene N. Roth was its president, and H.L. Sims was the first cashier. The bank was located in the building on the corner of West Fourth and St. Philip Streets. In 1929, the Bank of Lafourche and Citizens Bank of Lafourche merged, becoming Citizens Bank and Trust Company. The bank was headquartered in the old Green Street building of the Bank of Lafourche.

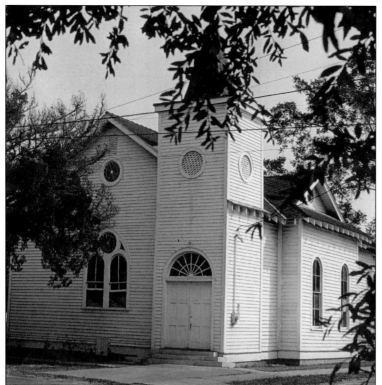

Calvary United Methodist Church was established in 1867 through the efforts of the Freedman's Aid Society, an organization that provided for the spiritual needs of freed black slaves. The society's representatives purchased the land for the church from a black woman named Rachel Tabor. In its early days, the church was used as a school for black children. The church was rebuilt in 1885 and renovated in 1976.

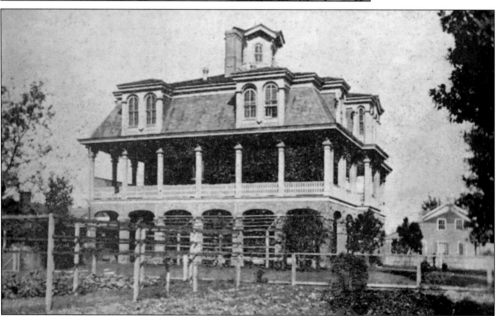

The iconic Dansereau House is located on the corner of Fifth and St. Philip Streets. The original home was a one-story house built in the 1840s by James A. Scudday. It was purchased by the Dansereau family of Canada in the 1860s. In 1875, Dr. Hercule Dansereau began remodeling the home into a three-story, Italianate-style mansion with a cupola. The architect was Henri Thiberge, a partner of Henry Howard of New Orleans.

The Lafourche Drug Store was originally opened on St. Philip Street next door to Dr. Sam Ayo's residence. The store was later relocated to the corner of St. Philip and Main Streets. Two brothers, Ed and Phil Naquin, were the proprietors of the drugstore. Pictured, from left to right, are Phil Naquin, Dr. Sam Ayo, Ed Naquin, and Cleveland Long.

The home of Dr. Sampson A. Ayo was located on the corner of St. Philip and West Second Streets. Dr. Ayo was born near Lockport on his father's sugar plantation. He was educated at Jefferson College and received his medical degree from Tulane in 1899. Dr. Ayo died at the age of 39 in 1911. The home was later remodeled and is now Rox's Bar. Next door is Rene's Bar, in what was the Lafourche Drug Store.

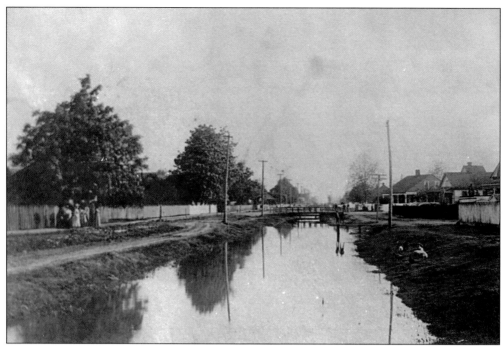

Canal Boulevard was once the site of a man-made canal. Around 1830, a canal was dug to reconnect Bayou Lafourche and Bayou Terrebonne. Although Bayou Terrebonne had originally branched off of Bayou Lafourche, it had gradually filled with silt. The canal was used heavily during the months of the year when the water was high. Later, wooden bridges were erected to connect the two streets. The street closest to town was Henry Clay Street, and the opposite road was called Lower Canal Street. The canal was covered in the 1930s. The large, two-story home in the photograph below was owned by Emile Lefort. The smaller house in front of it was owned by Dr. Louis Meyer. The corner of Dr. Albert Meyer's residence is on the extreme right. These three homes no longer exist.

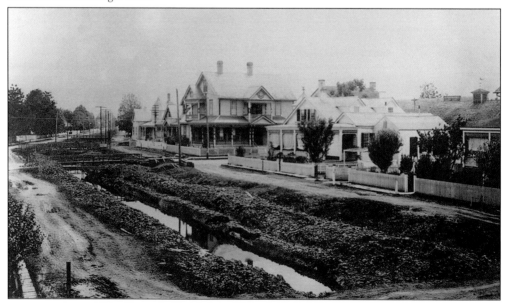

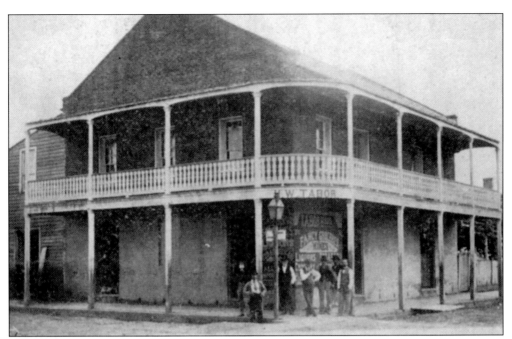

The Tabor Building is located on the corner of West Fifth and Green Streets. The building, dating to the 1840s, was originally owned by Hudson W. Tabor and passed on to his sons. Over the years, it was used as a grocery store, a warehouse, a dance hall, a garage, a restaurant, and law offices. The balcony was removed in the early 1900s.

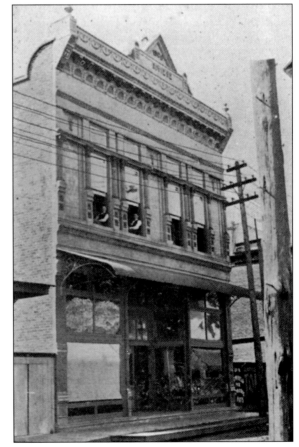

The Henry Riviere & Company Building is located on Main Street near Green Street. It was built in 1900 as a general merchandise store. The front of the structure features pressed metal. The building was later known as Leon Blocks, and then Jakes.

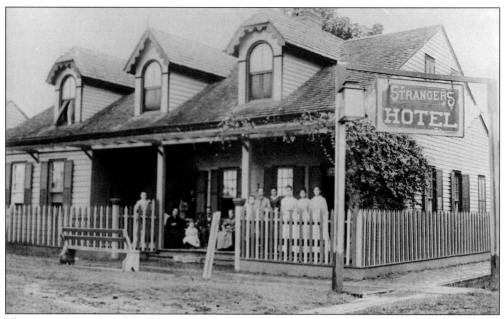

The original Stranger's Hotel dates back to the mid-1800s. It was owned and operated by Francisco Capella. After Capella's death, his widow, Cecilia, and her second husband, Thomas Alberti, ran the hotel. The photograph above was taken in the 1880s and shows the Alberti family on the front porch of the original building. The hotel was located on the corner of Green and Fourth Streets. It was later replaced with the two-story building seen below around 1890.

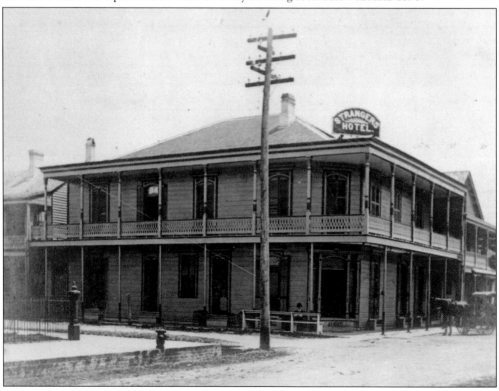

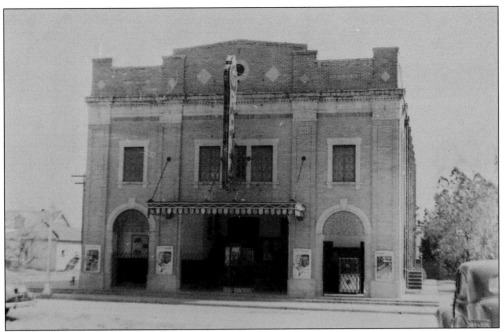

In 1919, the Stranger's Hotel was replaced with the Grand Theatre, which officially opened in June 1922. The building was designed by Joseph Robichaux, and the proprietor was Alex Blumensteil of Donaldsonville. Charles E. Delas, who served as Thibodaux's mayor from 1934 to 1954, was the manager. The theater also served as a civic center and hosted graduations and other noteworthy events. It closed in the late 1970s and was torn down in 1995.

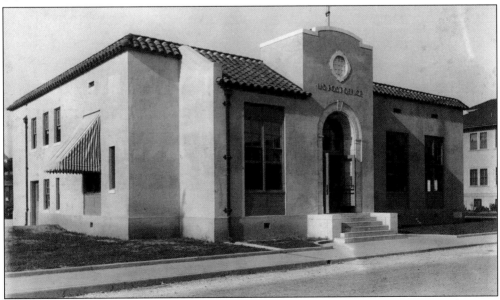

The old Thibodaux Post Office was constructed in 1925–1926 facing West Fifth Street between St. Louis and Green Streets. The post office was built on the former site of the Firemen's Hall, also known as the Thibodaux Opera House. The post office remained there until moving into a new building on Canal Boulevard in 1966. For many years, the old building housed the Lafourche Parish Public Library headquarters.

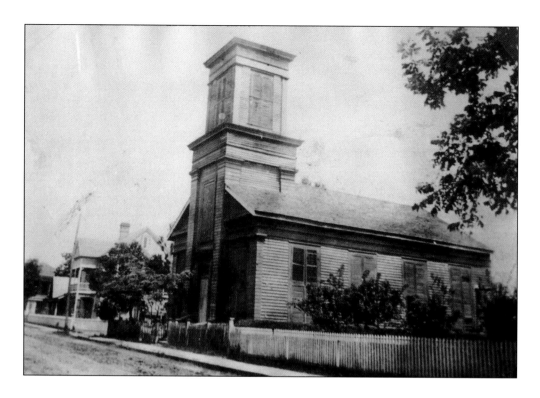

The Presbyterian Church of Thibodaux was formally organized in June 1847 by Rev. Daniel McNair. The first church, pictured above, was built on the corner of Fourth and St. Louis Streets. In 1907, a second church was erected on the corner of Canal Boulevard and East Eleventh Street. This building, pictured below, was destroyed by a hurricane in 1926. A third building was constructed on Green Street in 1927.

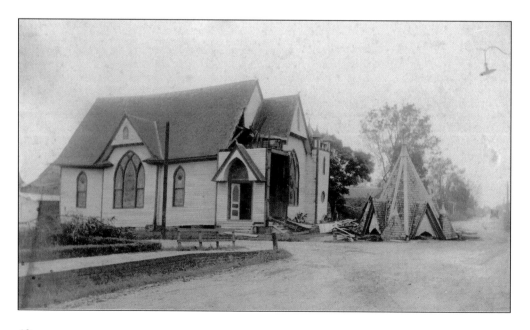

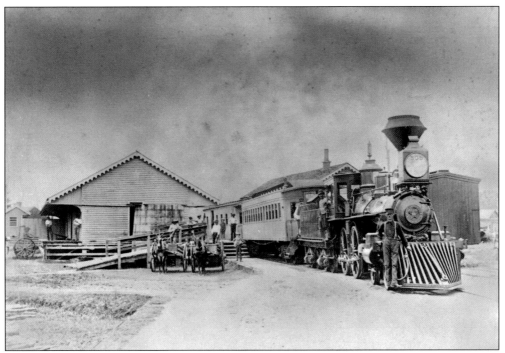

The Southern Pacific train depot was located next to the Thibodaux Foundry and the old Thibodaux Boiler Works, near Jackson and St. Mary Streets. The railroad and depot were constructed in 1878–1879, and the branch line was known as Morgan's Louisiana and Texas Railroad. It connected Thibodaux to the main line at Terrebonne Station (now Schriever). The depot remained in use until 1971 and was destroyed by fire a few years later.

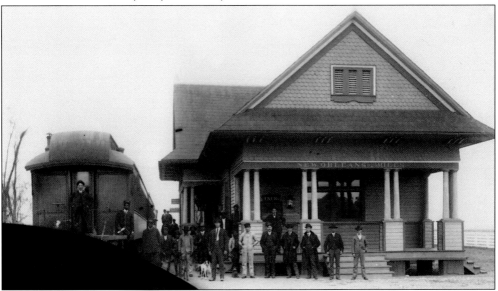

The Texas and Pacific Railway depot was located on the east bank of Bayou Lafourche at what is now the corner of St. Patrick Street and Highway 308. The railway, based in Texas, acquired several lines in Louisiana during the 1880s to connect Shreveport to New Orleans. The railroad also ran a branch line between Donaldsonville and Thibodaux for both passengers and freight.

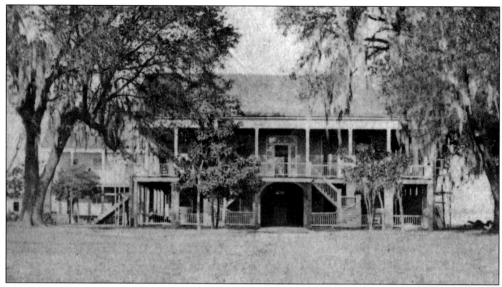

The Rienzi Plantation House, named for a 14th-century Italian patriot, was built on land that once belonged to Henry Schuyler Thibodaux, the namesake of the city. The house is believed to have been built between 1815 and 1835 by William Fields or Henry Johnson, who served as governor of Louisiana from 1824 to 1828. Other owners of the property included Thomas Bibb, former governor of Alabama; Juan de Egana; Richard Allen; and J.B. Levert. Unlike other plantation houses, however, the home features a cruciform hallway on both the first and second floors. Rienzi, as most plantations, had its own railroad. A system of narrow-gauge rails was built to transport sugarcane to the mill in boxcars powered by locomotives called "dummies." (Below, courtesy of the Morvant-Stevens family.)

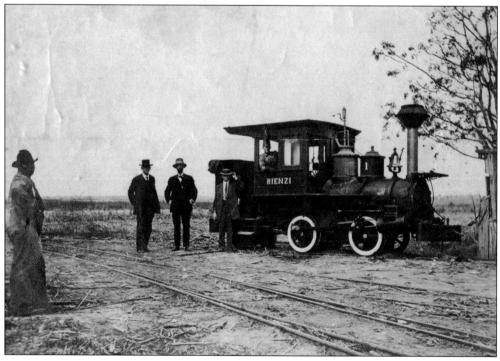

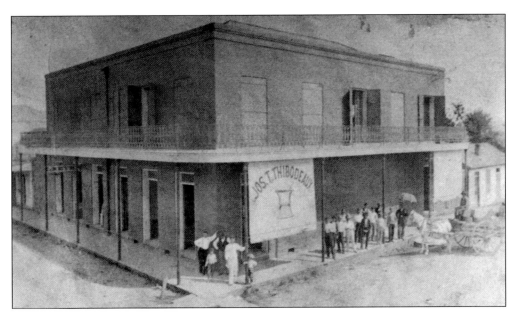

The Joseph T. Thibodeaux Building is located on the corner of Main and St. Philip Streets. The drugstore was on the first floor, and the second floor was used by the *Thibodaux Sentinel* newspaper. This was also the site of the second library in Thibodaux, which was established by the *Weekly Thibodaux Sentinel* in 1887. At the turn of the 20th century, the building was owned by Dr. Hercule Dansereau. Mr. F. Guillot was the pharmacist and manager. The store also featured a soda fountain, which can be seen in the photograph below. In later years, the building was the site of Rene's Bar and a Morgan & Lindsey Department Store, and it is now used as a nightclub. The balconies were removed many years ago.

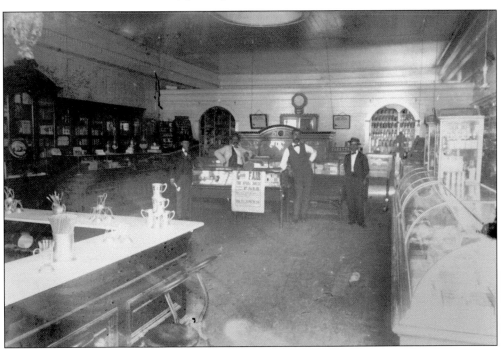

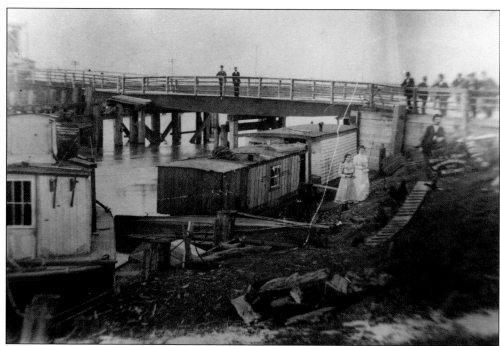

The early residents of Thibodaux used a ferry at the head of Maronge Street to cross over the bayou. The first bridge was erected at Jackson Street in 1857 by the Thibodaux Bridge Company, which sold stock. This bridge was destroyed in the Civil War by the Confederates evacuating the city in 1862. The Union troops constructed a bridge in its place, but its design prevented boats from passing. After the war, the bridge was rebuilt, and it opened in 1867. Pictured above is the bridge around 1902. In the foreground is Mr. Pledger, a photographer, along with his wife and daughter. In the photograph below, the view looking towards town shows the bridge during high water. After the bayou was dammed, the levees were removed and the bridge was lowered to street level around 1912. In 1938, a new metal, lift-span bridge was constructed. The lift mechanism and framework were later removed.

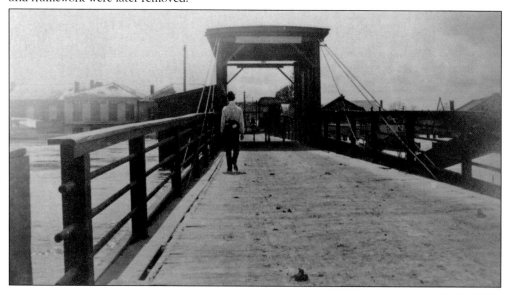

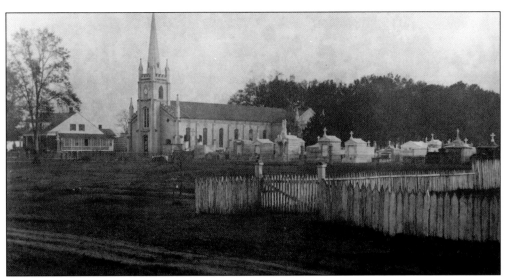

St. Joseph Catholic Church, in Thibodaux, was erected by Père Charles Menard next to the present-day St. Joseph Cemetery. The cornerstone of the church was laid on February 27, 1848, and construction was completed in 1849. This structure replaced an earlier wooden church built in 1819. St. Joseph is the oldest church parish in the Catholic Diocese of Houma-Thibodaux and is known as the mother church of the surrounding area. All early records of baptisms, confirmations, and marriages were recorded at St. Joseph. The interior of the church was stenciled and hand-painted. The hand-carved pulpit was hewn from a mahogany log salvaged from the bayou by a local craftsman. On May 25, 1916, the church was destroyed by fire. Only a few items were salvaged from the blaze, including a relic of St. Valerie that had been obtained by Père Menard on a trip to Rome in 1867.

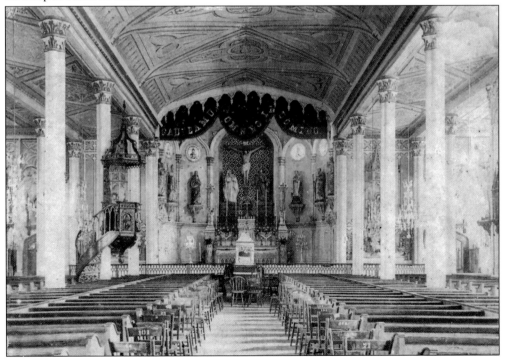

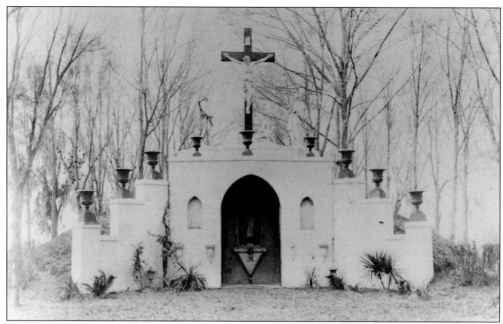

The Calvary Grotto and Shrine to Our Lady of Lourdes in St. Joseph Cemetery was constructed in 1883 by Père Menard. The calvary statues atop the mound, installed in 1884, were ordered from a Paris factory. They were made of cast iron and were originally painted to resemble stone. The grotto was created at the end of an alley of oak trees that Père Menard had planted in 1865 leading from the church.

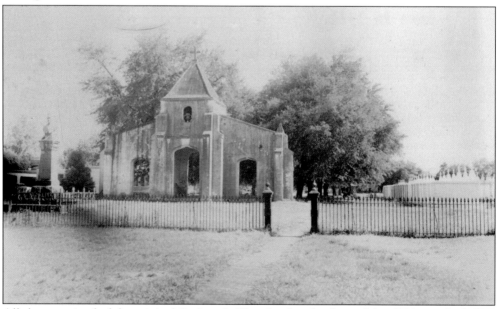

All that remained of the original St. Joseph Church after the fire in May 1916 was the belfry. After the fire, Father Alexander M. Barbier salvaged the fragments of the 1850 bell, and the Thibodaux Boiler Works, under the direction of Joseph Naquin, recast the bell. In December 1916, the restored bell was returned to the belfry, which was demolished in 1961 to make room for a mausoleum.

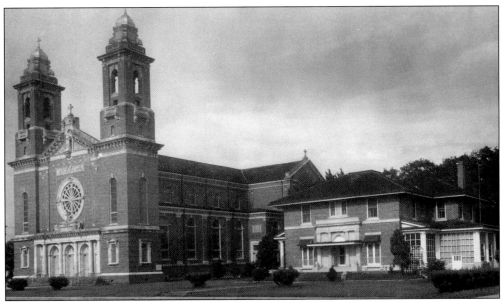

Designed in the Renaissance Romanesque style, the new St. Joseph Church was dedicated on January 25, 1923. New Orleans architects designed the exterior, and Joseph Robichaux, a local contractor, served as the exterior builder. The rose window in the rear of the church was modeled after that of the Cathedral of Notre Dame, in Paris. The altars are constructed of French, Italian, and Egyptian marble. The church was named a co-cathedral in 1977 for the newly formed Diocese of Houma-Thibodaux.

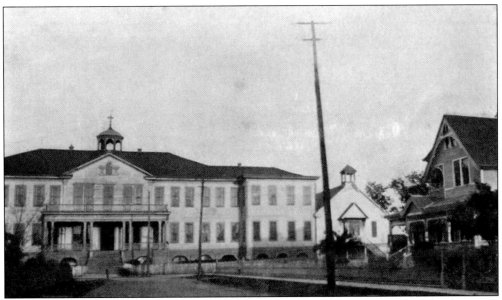

Mount Carmel Academy began its first school term on October 1, 1855. The school for girls was founded by Père Charles Menard and placed under the direction of the Sisters of Mount Carmel. The structure pictured was completed in 1900 and faced St. Charles and East Second Streets. The chapel was located just to the right of the main building. The school remained in operation until 1965, when it merged with Thibodaux College to form Thibodaux Central Catholic High School.

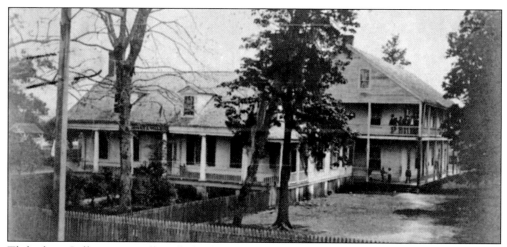

Thibodaux College, originally called Schifferstein Academy, was incorporated by the legislature in 1859. Shortly after, the school was placed under the direction of Père Charles Menard. The school pictured above was established along Highway 1, just south of Mount Carmel Academy, in 1872. From 1891 until 1894, the Brothers of Sacred Heart assumed direction of the school. The residence was used by the Brothers, and the two-story building in the rear housed classrooms on the first floor and rooms for boarders on the second. Pictured below is the new Thibodaux College building, erected just south of the old school in 1912 on property that had been donated by Cecilia Blake. The Brothers returned to manage the school for the 1912–1913 school year. The school operated until 1965. Both Thibodaux College and Mount Carmel were forerunners of what are now St. Joseph Elementary and Edward Douglas White Catholic High School.

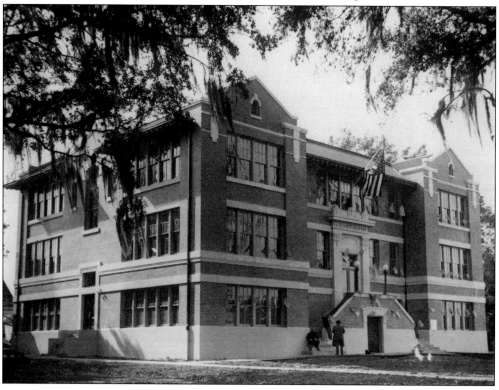

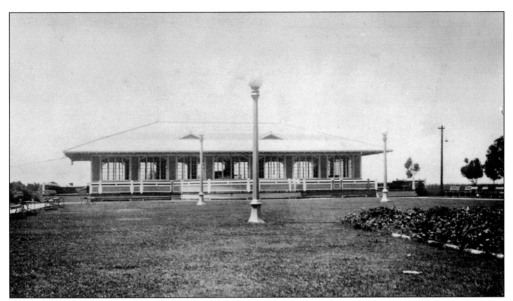

The Thibodaux Park Pavilion was built in 1917 near the bayou, in what was once a park and is now the site of city hall. Jitney dances and other public events, such as political rallies, were held in the building. In 1949, the building was sold and moved by barge to Galliano, where it was known as Bellvue Hall and, later, the Safari Club. The structure was destroyed by fire in 1977.

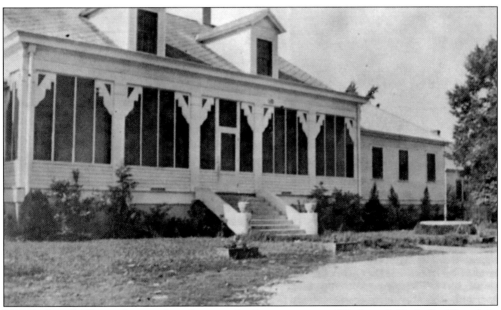

The St. Joseph Hospital opened its doors in the former rectory of St. Joseph Catholic Church in 1930. The rectory had remained empty for several years after the new church and rectory were built on Canal Boulevard. The hospital opened with 26 beds, and, in 1935, two wings were added to the old rectory, increasing the number of beds to 44. A new hospital replaced the structure in 1951.

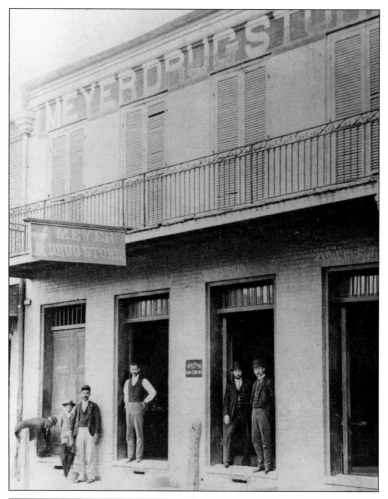

Meyer Drug Store was opened in 1889 by Drs. Albert J. and Louis E. Meyer. Both Meyers were graduates of Tulane Medical School and served as medical examiners for several insurance companies. The building was formerly owned by their father, Louis J. Meyer, and was located on Main Street near Jackson Street. Standing in the left doorway is druggist F. Guillot, and Drs. Louis and Albert Meyer are in the door to the right. Pictured below are, from left to right, Henry Lagarde, John Pierson, Edgar Riviere, Dr. Albert Meyer, and Dr. Louis Meyer.

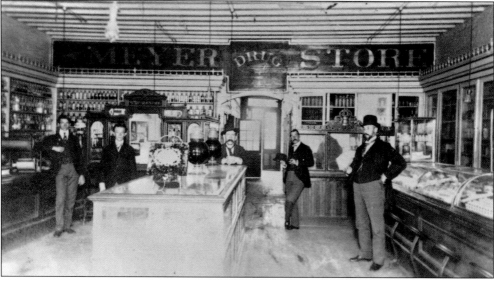

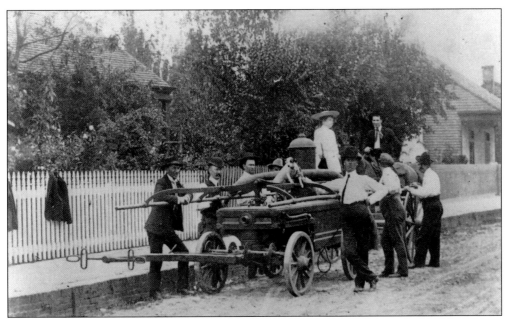

This photograph of the water pump of Thibodaux Fire Company No. 1 was taken about 1902 on Green Street. The pump had been purchased in 1859, one year after the company was organized. Pictured are, from left to right, (in the front) Charles Fleetwood, Eugene Knobloch, and Charles Riviere; (standing in the truck) Phil Naquin; (on the back side) Max Dupre, Lawrence Keefe, Fernand Dupre, and ? Trahan.

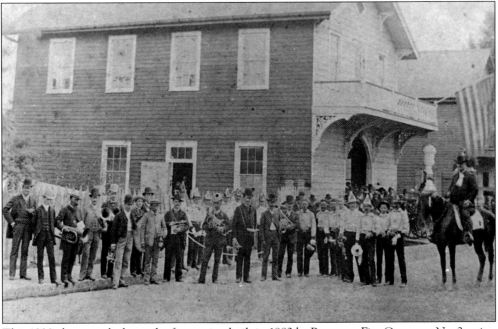

This 1888 photograph shows the fire station built in 1883 by Protector Fire Company No. 2, using proceeds from the fireman's fair. The structure, which housed an engine house and a hall, was located on the corner of Jackson and West Fourth Streets. Pictured is the Thibodaux Brass Band that marched in the fireman's parade that year. Grand marshal Taylor Beattie is on the horse.

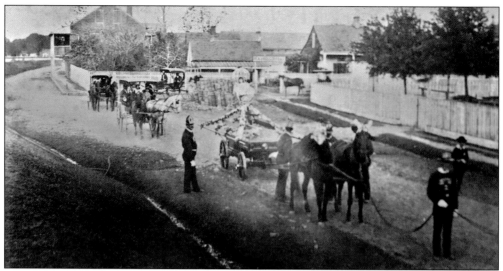

The Thibodaux Fire Department was incorporated in 1874 through the merger of several fire companies. The annual Thibodaux firemen's parade began in the mid-1800s, possibly dating to 1857. Each parade is led by the grand marshal, who is on horseback. The annual fair was a later addition that was used to raise funds for different projects. One of the first fairs documented was in 1883. The original fairgrounds were located on West Fifth Street between Green and St. Louis Streets. This parade scene is on First Street near the Phillippeau Building.

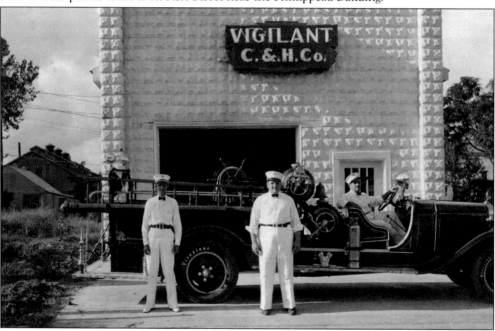

Members of the Vigilant Chemical & Hose Company fire company pose in front of the fire station with their 1927 fire truck, built by Drexler Motors of Thibodaux. The company was originally organized in 1887 as the Badeaux Bucket Brigade by Edward Badeaux. The name was later changed to Thibodaux Bucket Brigade, and, in 1920, the company became the Vigilant Chemical & Hose Company. The 1927 truck was equipped with both chemical and water hose supply. Pictured, from left to right, are Henry Adams, Frank Musso, and Sidney George in 1942.

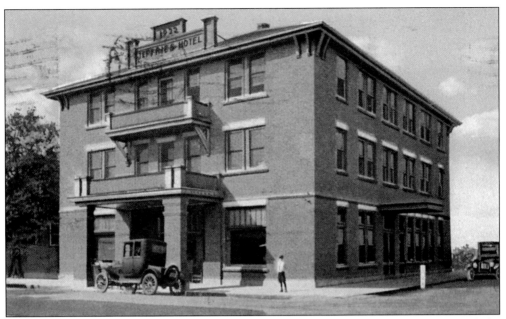

The Jeffries Hotel was built by William H. Jeffries in 1921–1922. It was located on St. Philip and West Fifth Streets. Jeffries also owned the West End Foundry, located on Highway 308, with his family. The first hotel was destroyed by a fire in 1926 and was rebuilt by Jeffries in the same location. In 1936, the hotel was purchased at auction by Paul Cancienne. The building was converted to apartments in the 1970s.

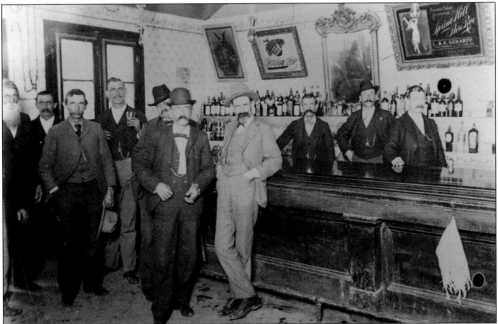

Lasseigne's Saloon was located on Main Street near the site of the Drexler Motors building. This photograph was taken about 1904. Pictured, from left to right, are John Seely, unidentified, Henry Scineau, Frank Richard, Adrian Roger, Tom Key, Clay Caillouet, Charles Lasseigne, Bebe Trone, and Nick Lasseigne.

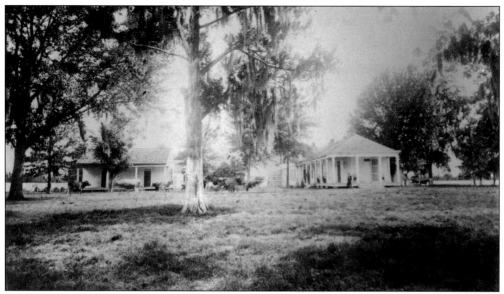

The Acadia Plantation House was located just south of the Nicholls State University campus in Thibodaux. The property was owned from 1827 to 1831 by brothers Stephen, Rezin, and James Bowie, of Alamo fame. Other owners included Philip Barton Key, a nephew of Francis Scott Key; and Andrew Donelson, the nephew of Rachel Jackson and Pres. Andrew Jackson. The property was purchased at auction in 1875 by US congressman Edward J. Gay, whose descendants owned the home and plantation until 2003. In the late 1880s, congressman Andrew Price and his wife, Anna "Nannie" Margaret Gay, formed the main house (below) by consolidating two early creole cottages and a shotgun house (shown above). After the structures were joined, the home was raised seven feet and renovated in the Queen Anne style of architecture, which was popular during the time. The home was torn down in 2010.

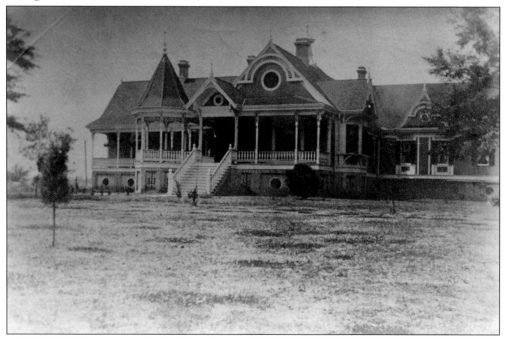

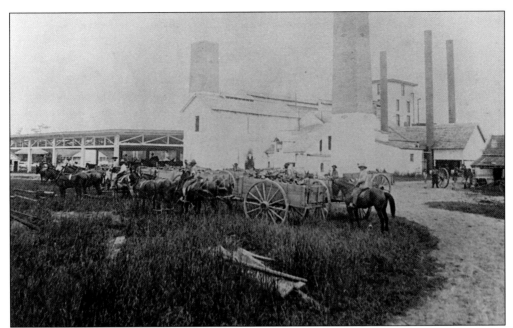

The Bowie brothers owned 1,800 acres and are reputed to have had the first steam-powered sugarcane mill in the state. Descendants of the Gay and Price family amassed over 3,000 acres of property comprised of the Acadia, St. Brigitte, and Evergreen sugar plantations, which all supplied the mill. Acadia's sugar mill was constructed around 1850 and remained in operation until 1926. In the 1880s, a dairy was also established on the plantation that operated until the 1940s.

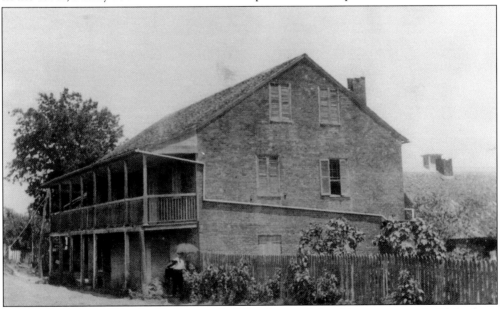

Dating to the late 1820s, the Phillippeau Building is one of the oldest structures in Thibodaux. Named for the Phillippeau family, who owned it beginning in the 1830s, the building faces Bayou Lafourche at West First Street between Maronge and Patriot Streets. It has served as a residence, a trading post, a bakery, a warehouse, a savings and loan, a bank, and sheriff's offices. In 1981, the building was connected to a new three-story structure.

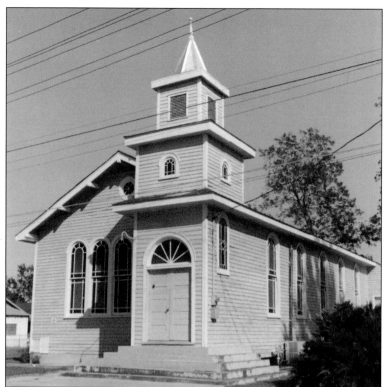

Mount Zion Baptist Church was organized in 1875 and was originally called the First Baptist Church of Thibodaux. The first church building was constructed in 1882. Baptisms took place in Bayou Lafourche at the head of St. Charles Street, near Mount Carmel Convent. The first church was destroyed in the 1926 hurricane, and a new church was dedicated in 1927.

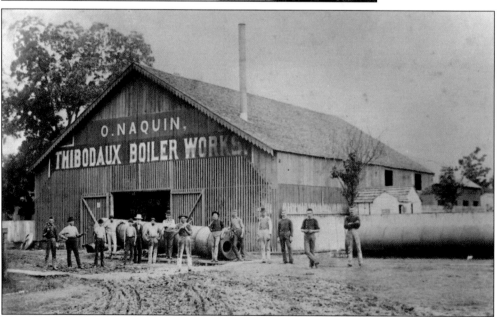

The Thibodaux Boiler Works was established in the early 1880s. Ozeme Naquin ran the company, which manufactured and repaired boilers for the local plantations' sugar mills. He also produced sheet iron. In 1901, he merged his business with Louis Braud & Company. During World War II, the company produced shells for the war effort and received the Army-Navy "E" award for its production during the war.

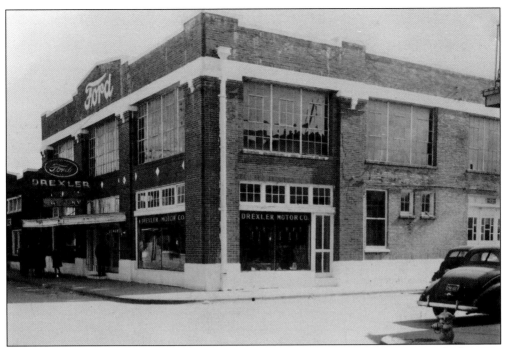

The Drexler Ford dealership was located on the corner of Main and Focus Streets. The business began as a livery stable known as Drexler's Sale Stables. Dr. Joseph L. Drexler, the son of the owner, was a trained veterinarian and a part-owner of the stables. The business eventually evolved into the automotive business when, in 1918, Joseph and his brother Simon purchased the Ford dealership from Charles and William Martin, who ran Martin's Garage. The Drexlers also ran a service station behind their dealership, on West Fourth Street.

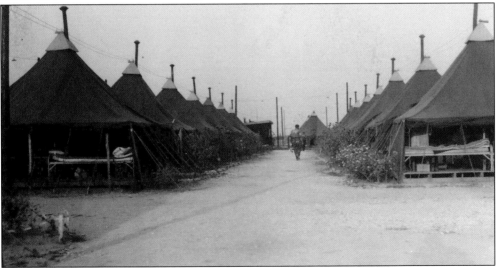

During World War II, there was a shortage of workers needed to harvest sugarcane on area plantations. Through the efforts of local politicians, several prisoner-of-war camps were established in the region. These German prisoners were used on plantations and were housed in camps located at Thibodaux, Mathews, and Valentine, as well as at other locations in nearby parishes. The camp pictured here was located in North Thibodaux.

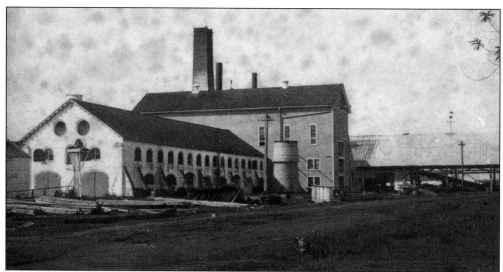

The land that is now Laurel Valley Plantation was originally a land grant to an Acadian named Etienne Boudreaux in 1785. In 1834, the plantation was purchased by Joseph Tucker. Under his ownership, the plantation increased in size and production. Tucker is responsible for building the c. 1845 sugar mill, seen in the photograph above. The ruins of this antebellum mill still exist. In 1893, J. Wilson Lepine Sr. and Frank L. Barker purchased Laurel Valley. They added to their landholdings, remodeled the sugar mill, and were responsible for building a railway system to transport cane to the mill from Laurel Valley as well as surrounding plantations. The mill ceased operations in the 1920s due to the mosaic disease, which devastated sugarcane crops. The boardinghouse seen below was built around 1900 and was used to house skilled workers during grinding season. It contained a kitchen and dining and meeting areas downstairs and bedrooms upstairs.

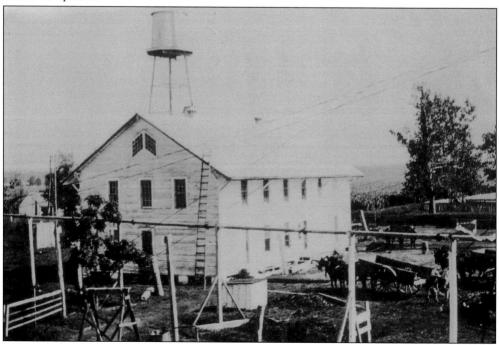

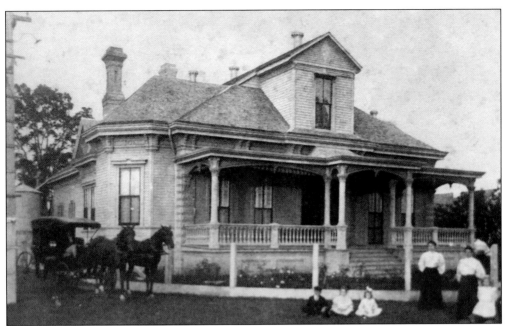

Laurel Valley is the largest surviving 19th-and-early-20th-century plantation complex in the United States. The approximately 60 buildings that remain today date from the 1840s to the 1920s. In addition to the ruins of the mill, many of the workers' homes, the plantation store, and the schoolhouse, as well as various outbuildings, have survived. The original plantation house burned around the time of the Civil War. A later owner, Burch Wormald, built the home seen above in the 1880s. The photograph below shows some of the workers' homes and the plantation bell, which called laborers to and from work. The plantation railroad track can be seen in the foreground. The property is still an operating sugarcane plantation and is owned by heirs of the Lepine family.

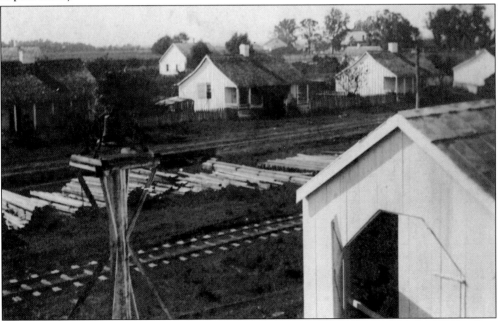

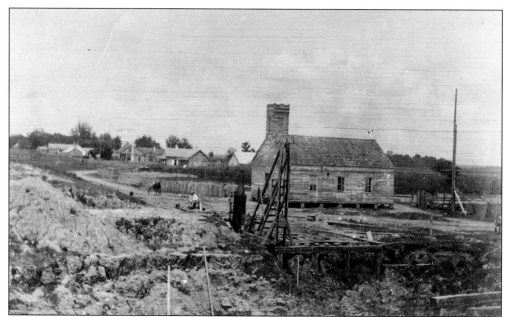

Old Fountain Missionary Baptist Church and its cemetery are located on the edge of Laurel Valley Plantation. This photograph dates to the early 1900s and shows a small, frame church building possibly built in the 1870s. The original church was known as the "Old Fountain Church." This church burned and was replaced with the present structure. The bridge under construction is along Highway 308, over the Laurel Valley Canal.

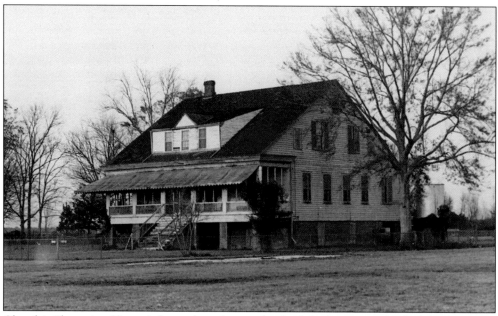

Chatchie Plantation House is located on the east bank of the bayou, south of Thibodaux. The home was built by Justin Gaudet around 1868, on the site of an earlier house that had served as a hospital during the Battle of Lafourche Crossing, just south of the homesite. The antebellum kitchen was later attached to the present home. The dormer window, a later addition, was removed during a restoration in 1978.

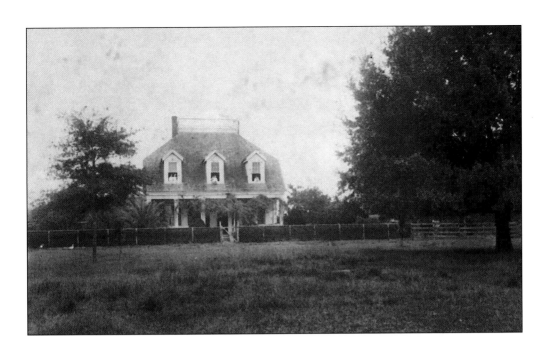

Guillaume Alfred Coignet, a native of France, was married to Charlotte Emérante Gaudé. Their first home was on Morning Star Plantation, just south of Thibodaux. After his wife's death in 1869, Coignet married Stephanie Gaudé and moved his family to Octavia Plantation, located three miles south of Thibodaux on the east bank of Bayou Lafourche. In 1895, the Coignet family moved into their newly constructed home, pictured above. The family managed the plantation and lived in the home until 1913, when they relocated to Thibodaux. The daughters of the family then opened a shop that specialized in custom-made dresses and hats. The Octavia home and property were later acquired by Judge P. Davis Martinez. The photograph below is an early view of the Octavia sugar mill.

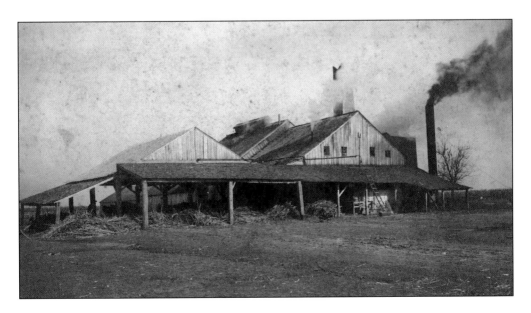

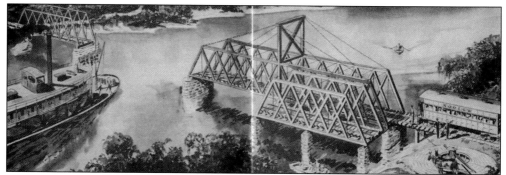

The railroad bridge over the bayou at Lafourche Crossing was constructed in 1855 by the New Orleans, Opelousas & Great Western Railroad, which ran from Algiers to the west. The original bridge, pictured above, was comprised of one fixed and two sliding spans that were operated by manpower and mules. This bridge was replaced in 1860 by a swinging drawbridge that was destroyed during the Civil War. The bridge was rebuilt in 1866. The photograph below was taken in the late 1800s, with a view looking east from the bridge.

Three

CENTRAL LAFOURCHE
ST. CHARLES, RACELAND, MATHEWS, GHEENS, AND LOCKPORT

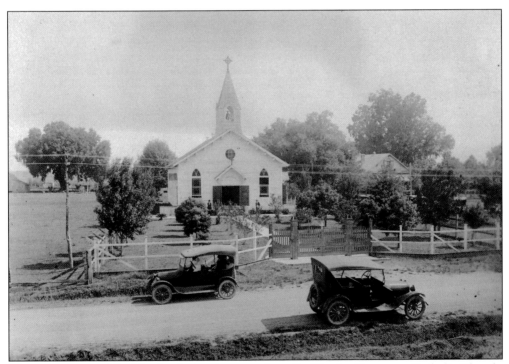

The community of St. Charles derives its name from St. Charles Borromeo Catholic Church. The chapel and school were established in 1874 by Père Charles Menard. The parish was officially dedicated in 1912, followed by the consecration of a new wooden church two years later. The former chapel was named for the first pastor, Albert Mauret, and moved to the back of the new church and used for religious education and a church hall. (Courtesy of Phyllis Toups Robichaux.)

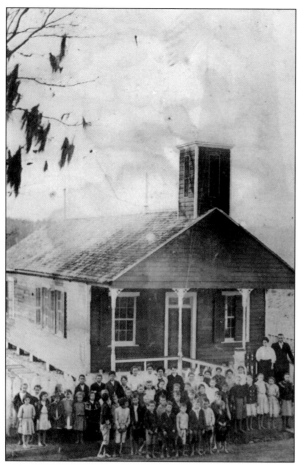

The Scott School (left) was located on land donated by Paul Scott in 1904. The structure was an old store that was located on the property and sold to the parish school board. Scott was a member of the school board for many years and was active in building many local schools. The Toups School (below) was built on land donated by Mrs. Zephrin Toups in 1903. Mrs. Toups, the former Marie Adele Chauvin, died in 1933. Both the Scott and Toups Schools were closed in 1919 after the construction of St. Charles High School. (Left, courtesy of Brad France; below, courtesy of Bayou Lafourche Folklife Museum.)

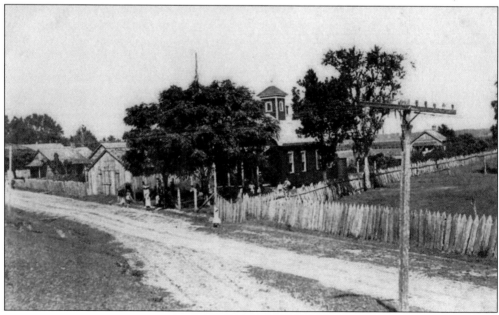

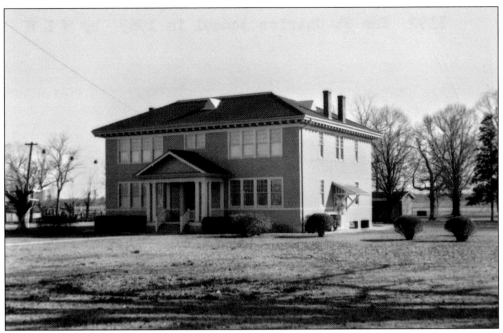

St. Charles High School was one of four school buildings constructed in 1918 and 1919 in the parish. It made possible the consolidation of three smaller schools in the area: Prosper Thibodaux, Paul Scott, and the Toups School. The new building was constructed between the Thibodaux and Scott Schools and across the bayou from the Toups School. The high school department was closed after the 1943–1944 school year, and the building now serves as an elementary school.

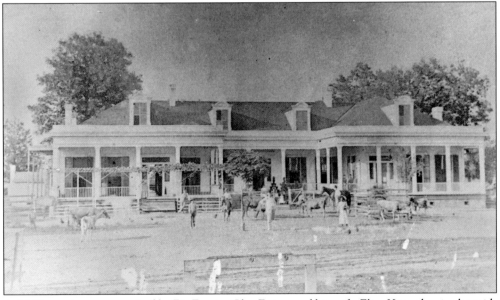

Ariel Plantation was acquired by Dr. Fayette Clay Ewing and his wife, Eliza Kittredge, in the mid-1800s. Ewing lived at Ariel until his death in 1872. The plantation was purchased by Prosper T. Toups in 1885. The home, which consisted of 21 rooms, was partially dismantled in the 1940s. The left wing, or one-third, of the original home still exists along Highway 308, south of the St. Charles community. (Courtesy of Philip J. Toups Jr.)

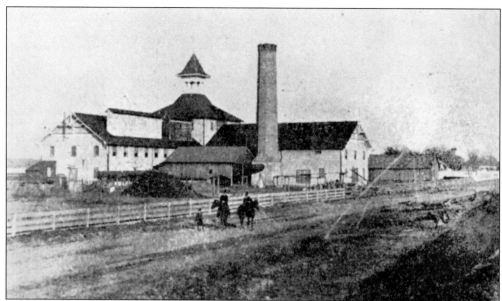

The Bush Grove Plantation is located on the east bank of the bayou in the community of St. Charles, just north of the Catholic church. The plantation consisted of 3,000 acres, with 1,000 cultivated in sugarcane. The property had a succession of owners in the 1800s, including Alexander Lepine, Paul Justilien Theriot, Gustave Sabatier, Edmond Souchon, and Joseph C. Rousseau & Bros. In the late 1880s, the plantation was purchased by J. Walter Libby and Louis A. Blouin, who made improvements to the mill and operated a nine-mile railway system that transported sugarcane from area plantations to the Bush Grove mill. These photographs show the front and back views of the sugar mill. The large brick smokestack in the photograph above was built in 1883.

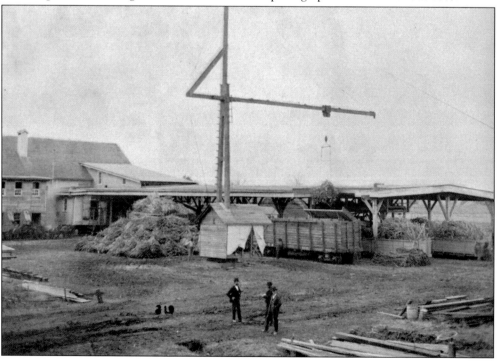

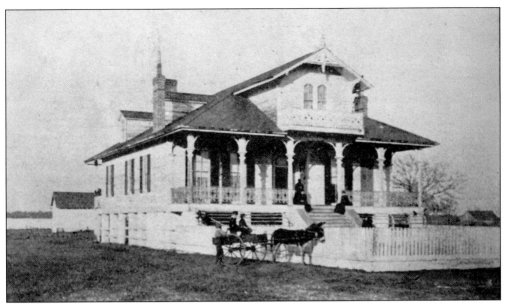

This is the home of Louis A. Blouin, who owned Bush Grove from the 1880s until his death in 1918. While Blouin lived on and ran the plantation, his business partner J. Walter Libby lived in New Orleans.

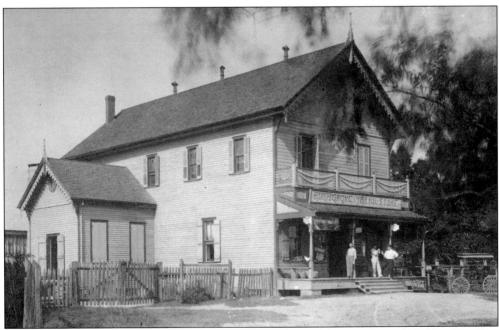

The Bush Grove store was a large plantation store that sold general merchandise as well as plantation supplies. It was operated in the 1870s and 1880s by Joseph Clay Rousseau & Bros. The Rousseau brothers leased the plantation from Dr. Edmond Souchon. It is believed that the nearby Rousseau railroad depot was named for this family. (Courtesy of Phyllis Toups Robichaux.)

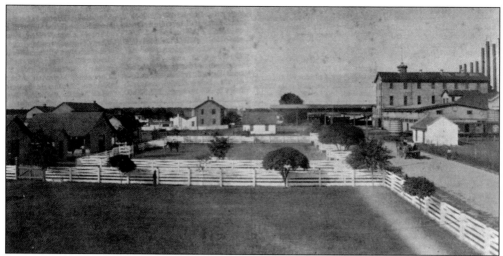

Owned by the Kittredge and Ewing families from the 1850s to the 1870s, Raceland Plantation and Sugar Mill is thought to be named after George Race, husband of Dr. Ebenezer Kittredge's daughter. In the 1880s, the plantation was purchased by Leon Godchaux, who consolidated the mills on his numerous plantations into a central mill on Raceland Plantation that he had updated in 1893. This mill received sugarcane for grinding by barge and rail from several area plantations, including Utopia, Mary, Upper Ten, and Theriot. Cane was also transported from Godchaux's plantations in other parishes. He installed a narrow-gauge railroad named the Lafourche, Raceland & Lockport Railroad, which stretched 15 miles from his Raceland mill to area plantations. The sugar mill is still in operation today. The photograph above was taken around 1900. The aerial view below was taken in the mid-1900s. (Above, courtesy of Martin L. Cortez; below, courtesy of Bayou Lafourche Folklife Museum.)

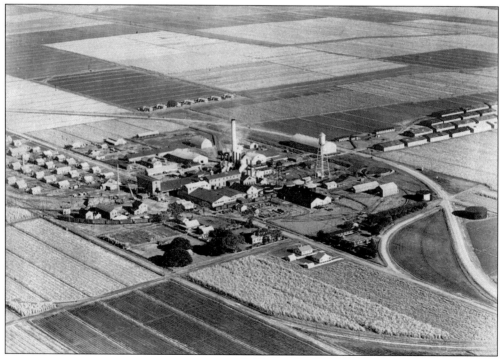

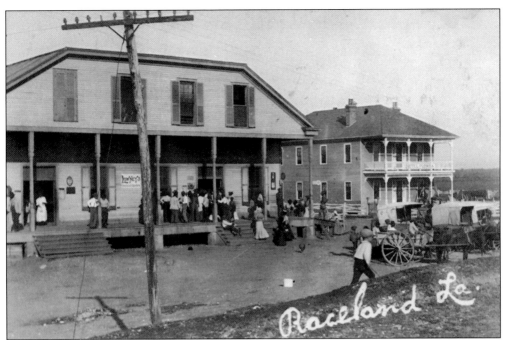

Simon Abraham owned one of the largest mercantile businesses in the parish. The S. Abraham Store was established in 1876 and was located on the east bank of the bayou near the first Raceland bridge, seen in the photograph below. The store seen above was built around 1898, after the first store burned. The business stocked groceries, dry goods, clothing, hats, shoes, plantation supplies, furniture, hardware, and liquor. In addition to operating the store, Abraham served as paymaster for the Godchaux mill and plantations. Emile Kahn was the manager of the store. The Hotel Florida and Livery Stable, next door, was established around 1907 by Emanuel Montecino and managed by J. Montecino. The hotel could accommodate 20 people. In the 1960s, the Abraham Store was moved a short distance away and became Zeringue's Furniture Store, which was destroyed by fire in 1993. (Above, courtesy of Brad France; below, courtesy of Martin L. Cortez.)

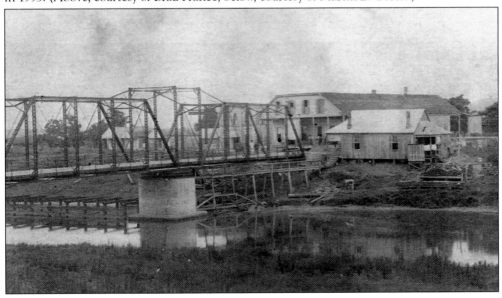

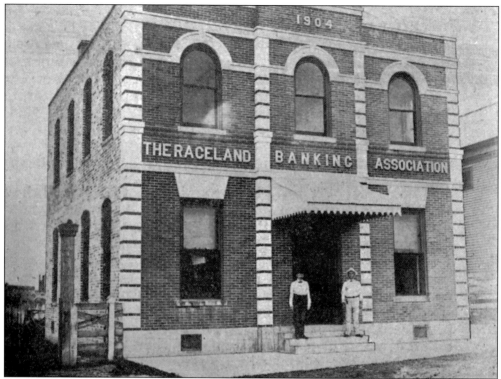

The Raceland Bank was erected in 1904 by the Raceland Banking Association next to the S. Abraham Store. The bank opened for business on January 10, 1905. The facade of the building was made of pressed brick. Jules Godchaux served as president, Charles Mathews as first vice president, Dalmas Robichaux as second vice president, and Simon Kahn and H. Chauvin as cashiers.

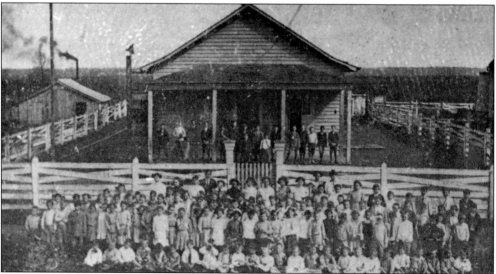

This photograph of the Raceland School was taken in 1911, shortly before the school was consolidated into Raceland High School. This school was located at the front of the Raceland Plantation. Clotilda Lyall and Cecilia Chauvin were the first teachers. (Courtesy of Bayou Lafourche Folklife Museum.)

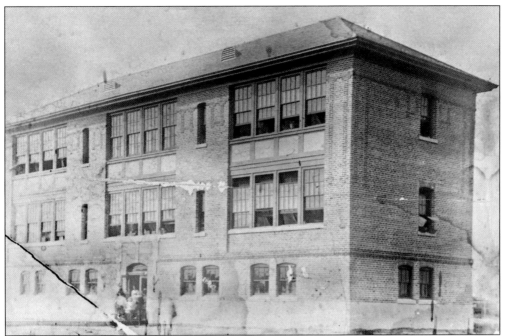

Raceland High School was built in 1912 and was one of three schools built courtesy of bonds passed in 1911–1912. The building was enlarged in 1924, with matching wings added to the structure. There was also a teacherage built next to the property, which served as a boardinghouse for school faculty. The school served as a high school until 1966, when it merged with Lockport High School to become Central Lafourche High School. The building now serves as an elementary school.

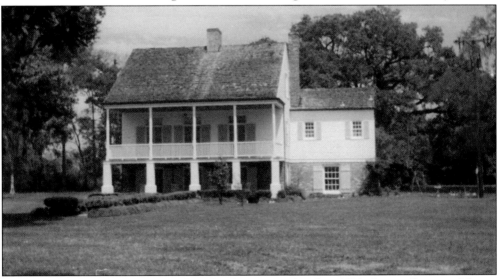

The Rosella Plantation Home, in Raceland, was completed in 1814. Originally named for its builder, the house was first known as the Jean Baptiste Thibodaux Home. After the death of Thibodaux, his wife, Natalie Martin, married Evariste Lepine. Their son Oscar then named the plantation after his wife, Rosella Folse. The home and plantation were eventually inherited by the Ayo family through Alida Lepine, who was married to Dr. Jackson Ayo. Their son Dr. T. Benton Ayo owned the home until his death in 1985.

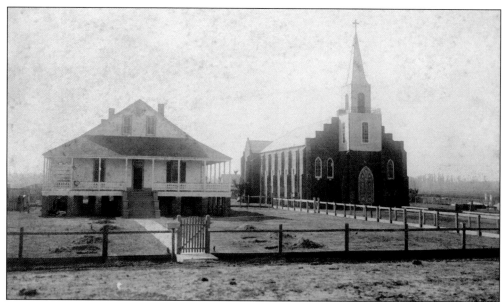

The site of St. Mary's Catholic Church, in Raceland, was dedicated for a cemetery and church in the early 1800s. The church pictured here was constructed in the early 1880s, and the rectory in 1905. Although the church was originally known for many years as St. Mary Pamela, the parish's official name was St. Mary's Nativity. The steeple, belfry, and facade of the church were remodeled in 1931. A new church was built in 1965–1966. The old church was demolished in 1983, but the rectory remains in use today. The early photograph of the cemetery below shows that many of the early graves were ground burials with wrought-iron crosses. Many of the early priests associated with St. Mary's are buried in the priests' tomb, located in the center of the cemetery under the crucifix and calvary statues. (Below, courtesy of Martin L. Cortez.)

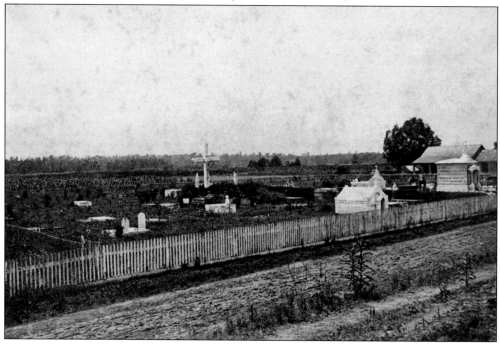

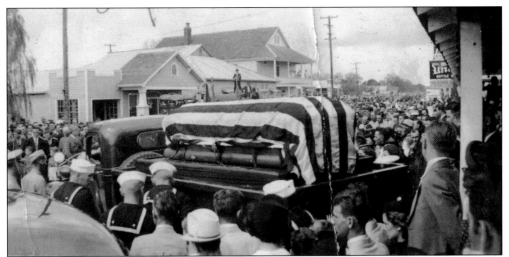

Freddie John Falgout, a Raceland native, was killed on August 20, 1937, aboard the USS *Augusta* in Shanghai Harbor, a day before his 21st birthday. He was killed by shrapnel from a Japanese antiaircraft shell. His death is regarded as the first US military casualty in what would later become World War II. His wake and funeral were held in Raceland, attended by thousands of mourners. The funeral procession began in town and led to St. Mary's Catholic Church and Cemetery, where he is buried.

The Theriot Plantation Home, located just south of the Theriot Canal on Highway 308, was built in 1891 by Alexander L. Theriot. He was the son of Paul Justilien Theriot, who owned several area plantations, including the Home Place and Scudday Plantations. The house replaced an earlier residence destroyed by fire. The home and plantation was eventually acquired by Leon Godchaux and was used as a sharecroppers' home until it was purchased by the Wilson family in 1971.

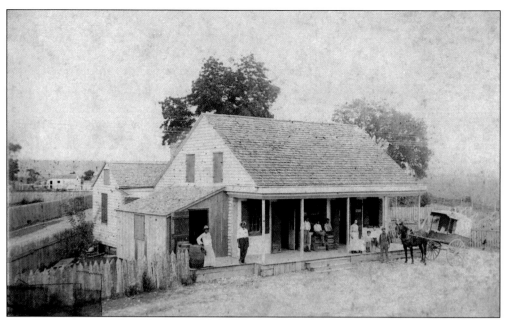

The Brocato store and residence were built before 1900 and purchased by Vincent Brocato in 1907 from Philip Culotta. Brocato was an Italian immigrant who came to the United States in 1885. The left side of the store was used for dry goods and groceries. The right side was used for a barroom, oyster bar, and candy counter. The residence was located behind the store. It is located north of Raceland on Highway 308. (Courtesy of Bayou Lafourche Folklife Museum.)

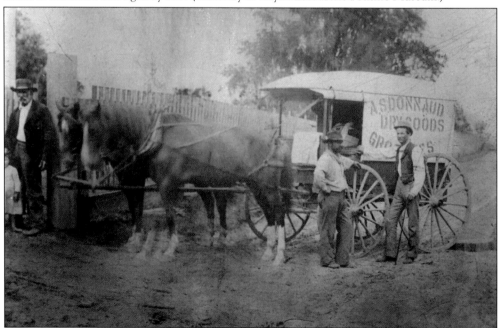

Peddling carts were used by many of the local merchants as a means of selling their goods to those customers who were not able to travel to the store. This photograph from around 1890 shows the peddling cart of Abel S. Donnaud on his route between Lafourche Crossing and Raceland. Donnaud is standing at the extreme right of the photograph.

The Raceland Theatre, seen here around 1919, was one of several theaters in the community. It was located near the Tokio Pavillion and was owned and operated by the Hillman A. Labat family.

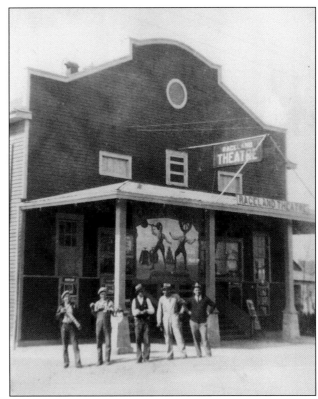

The Tokio Pavillion was built in 1919 and owned by Hillman Andrew Labat. The building served as a gathering place for residents of Raceland and the surrounding area for many years. After the bombing of Pearl Harbor by Japan in 1941, the name was changed to the Fun Pavilion. The building was later used as a warehouse and was torn down in 2003. Hillman is pictured on the left.

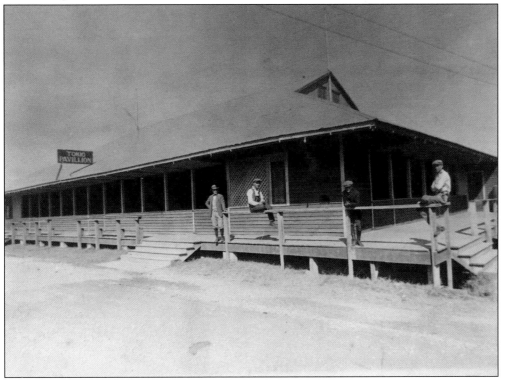

James B. "Dad" Hill was an inventor and farmer from Ohio who settled in Raceland in the early 1900s. He designed and patented several ditching and farm machines that helped drain swamp and marsh prairies in order to create more farmland. Because of his inventions, he was invited by Edward Wisner and the Louisiana Meadows Company to help with reclaimed land projects in southern Louisiana. One of his inventions was the Buckeye Traction Ditcher, which was made in Findlay, Ohio. Because of problems with heavy machines and soft Louisiana mud, Hill also designed an "apron tractor" with caterpillar tread wheels that was able to operate without getting stuck. This design was the forerunner of treads used on tanks and other military equipment. Pictured above is the Hill residence, located on his farm at Raceland. Hill is seen below on one of his plowing machines with tread wheels.

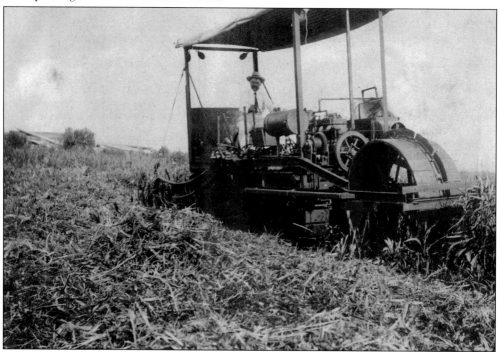

James B. Hill is credited with developing a variety of corn known as Hill's Yellow Dent, which yielded 60–80 bushels an acre. The photograph shows Hill harvesting corn from cornstalks that measured 16 feet tall. His farm, known as Sea Level Farm, was located on the Raceland Prairie and consisted of 160 acres. Part of the property is today known as Butch Hill after his son Cloyse A. "Butch" Hill.

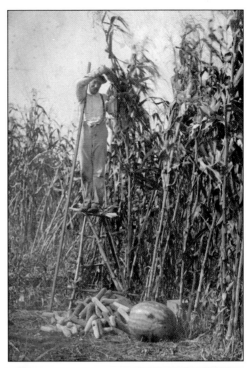

This is the Edward Wisner School, located on the Raceland Prairie. The school was named for Edward Wisner, who organized the Louisiana Meadows Company in 1907. The Raceland Prairie was one of Wisner's land reclamation projects. Wisner purchased thousands of acres of swampland and marshland in south Louisiana and then built levees and drained or reclaimed it for farmland.

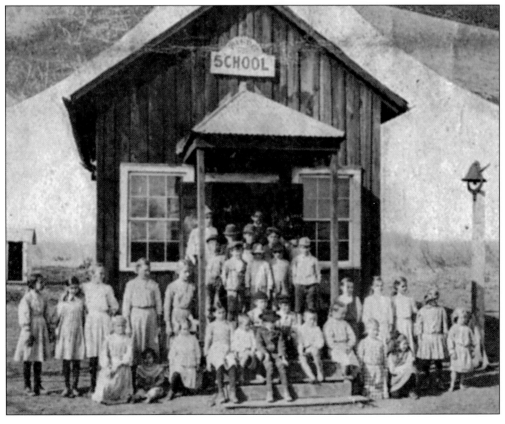

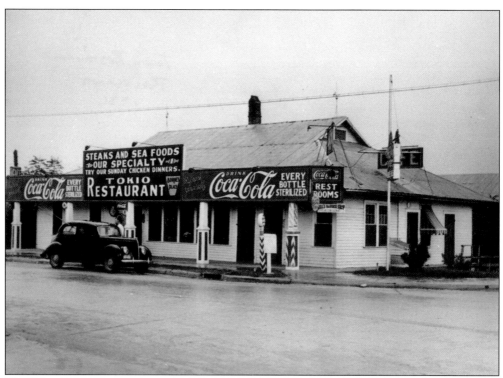

The Tokio Restaurant was located on the bayou side, next to the Raceland Bridge. This restaurant was also known as Borne's Café. The building also housed Bill's Barber Shop. This photograph was taken in 1936. (Courtesy of Bayou Lafourche Folklife Museum.)

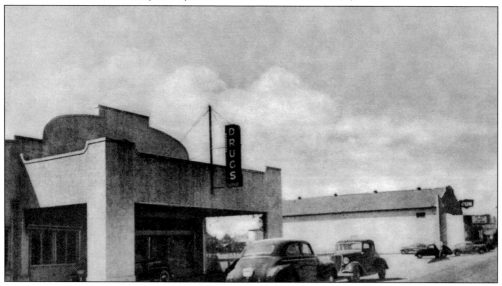

Ayo's Drugstore was established in 1924 by Dr. Jackson J. Ayo, who had previously served as physician for the town of Bowie. After Bowie was destroyed by fire, he moved his practice and drugstore to Raceland. In 1936, Ayo sold his business to his two sons, T. Benton and Jackson J. Jr. The drugstore remained in operation until 1976, when it was sold to Glenn Landry and Anne Norwood and renamed Landwood Pharmacy. The pharmacy finally closed in 1998.

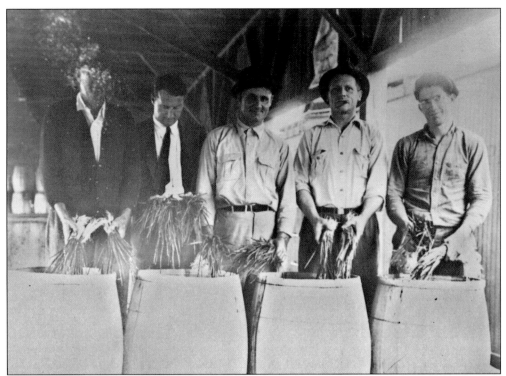

The Raceland packing shed of the Louisiana Vegetable Company was located near the railroad station and was used by local farmers, who brought truckloads of fresh Irish potatoes, shallots, cabbage, and corn. The packing shed employees would grade, pack, and load the vegetables into railroad cars for shipment. Pictured holding shallots are, from left to right, Anthony Palmisano, an unidentified company inspector, Edward Guidry, Camille Baudoin, and Onezipe Landry.

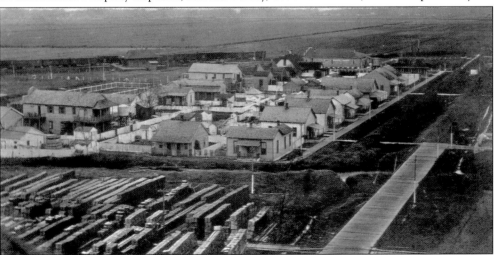

The town of Bowie was located on the east side of Bayou Lafourche just north of Raceland, behind Raceland Middle School. The town was developed around the Bowie Lumber Company, established by William Cameron in 1895. This aerial photograph shows a portion of the town, including the railroad, the train depot, several buildings and homes, and stacks of lumber in the lumberyard. (Courtesy of Martin L. Cortez.)

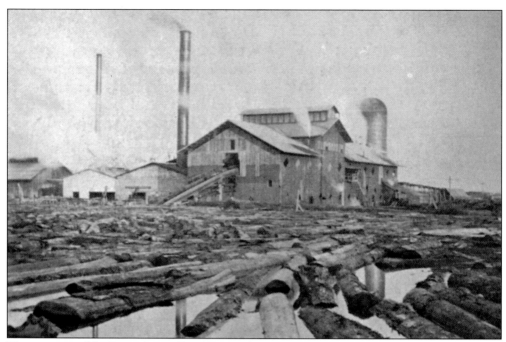

This is a view of the Bowie Sawmill and log pond in 1900. A system of canals was used to transport logs to the mill from the swamps. The company was known for manufacturing red cypress timber products, including crossties, laths, shingles, and building lumber. Nearby were the planing mill, the lathe and shingle mill, and the dry kiln. Other facilities were located at Coteau Folse, a community located in the swamp about three miles away.

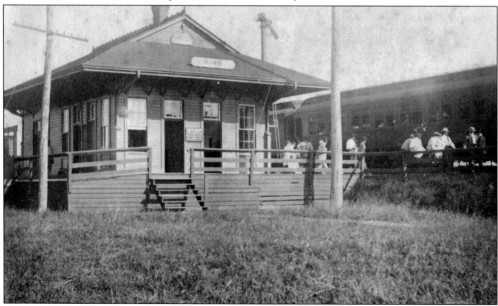

The town had its own railroad system, consisting of 20 miles of track that led from the mill and the town into the cypress swamps. This photograph shows the depot and the elevated railroad. In 1912, a levee break along the Mississippi River flooded much of the town, forcing many of the Bowie residents to live in tents along the elevated railroad.

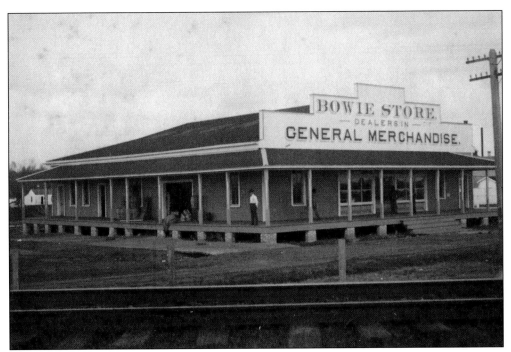

The Bowie Company Store and the Bowie Hotel, pictured here, were located along Main Street. There was also a bakery, a butcher shop, a drugstore, a post office, a blacksmith shop, a school, and two churches. At the mill's peak, the population of Bowie grew to approximately 1,500. The town was made up of several neighborhoods, including Michigan City, Little Italy, and Free Town. The mill and many of the buildings and homes were destroyed by fires in 1917 and 1924, which forced most of the inhabitants to move away. One of the few buildings that survived the fire, St. Andrew Catholic Chapel, was moved across the bayou near St. Mary's Church for use as a school.

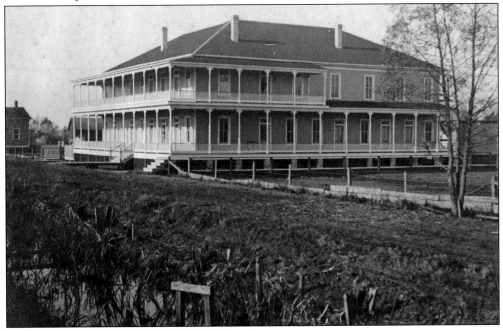

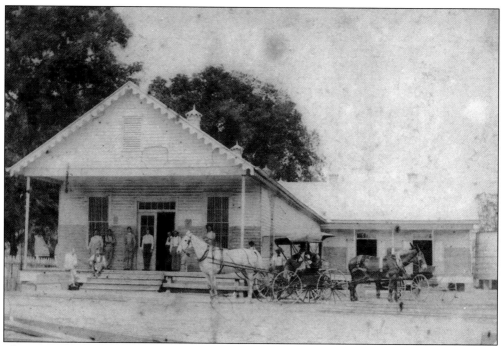

The Home Place Plantation Store was located on Highway 654 just before the Vacherie-Gheens community. The plantation was once owned by Raceland merchant Simon Abraham, followed by Charles S. Mathews, and then the South Coast Corporation. This early store was later replaced with a smaller store that was managed by Harry Breaux Sr. (Courtesy of Brad France.)

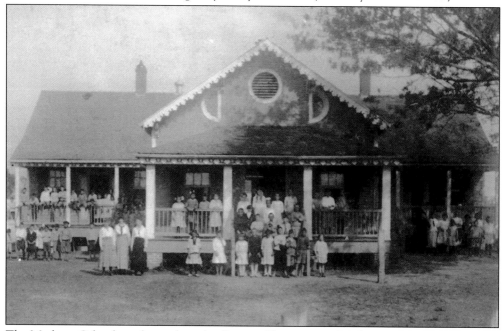

The Mathews School was located on the Georgia Plantation in Mathews, near the plantation's general store. The school taught children from the plantation as well as from the neighboring areas. The photograph was taken around 1910. (Courtesy of Brad France.)

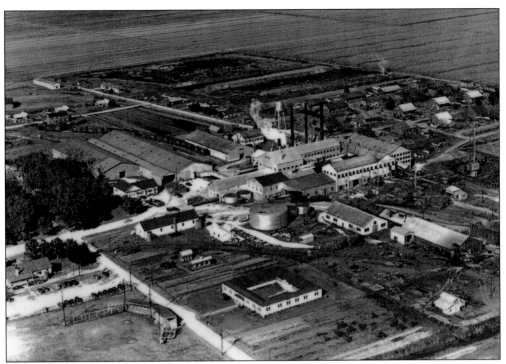

The Georgia Plantation was established in the early 1800s by Judge George Mathews and remained in the Mathews family for three generations. Charles Stewart Mathews, grandson of the original owner, operated the plantation until his death in 1923. In 1927, the property was purchased by the South Coast Corporation. The plantation had its own post office, drugstore, school, commissary, railroad station, mill for manufacturing raw sugar, and refinery for producing refined, granulated sugar. Several of these buildings can be seen in the aerial photograph above. The refinery was known for its White Gold brand of sugar, which was produced until the mill and refinery were closed in 1986.

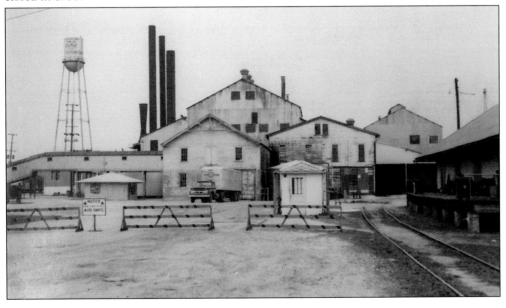

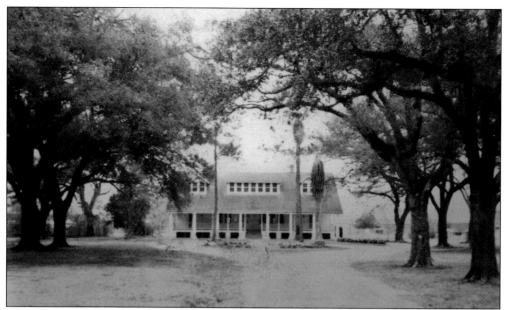

The original Mathews home on Georgia Plantation dates to the 1800s and was later used as office space by South Coast during its ownership. The home was sold and moved from its original site in 1991.

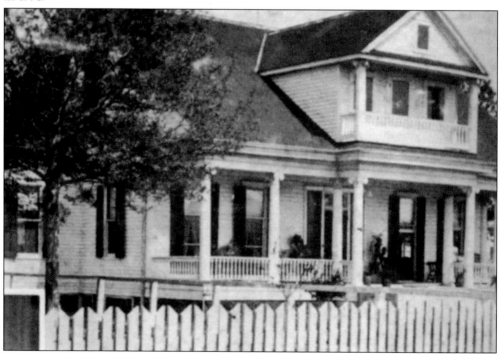

Ravenswood Plantation, located on Highway 308 near Lockport, had several owners during the late 1800s and early 1900s, including the Lyall, Leblanc, Barker, and Bourg families. Unlike many of the plantations, the main house was not constructed near Bayou Lafourche, nor did it face the bayou. Rather, it was built in the middle of the plantation, facing the Company Canal. (Courtesy of Bayou Lafourche Folklife Museum.)

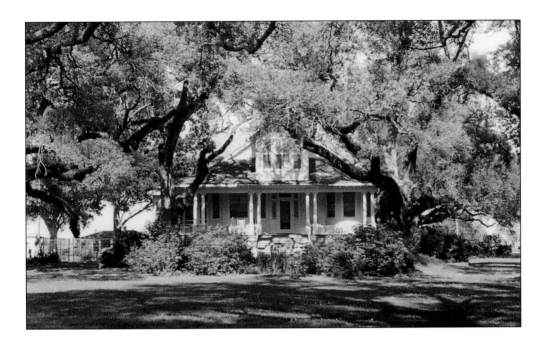

Clotilda Plantation has been associated with the Barker family since the late 1800s. It was previously owned by the John Lyall and J. Lovincy Leblanc families. The plantation is presumably named for Lyall's wife and daughter, who were both named Clotilda. The sugar mill closed in the early 1900s. The present home, which replaced an earlier structure, was constructed in 1908 by Frank L. Barker. His descendants still own the home and plantation. (Both, courtesy of Clotilda Plantation.)

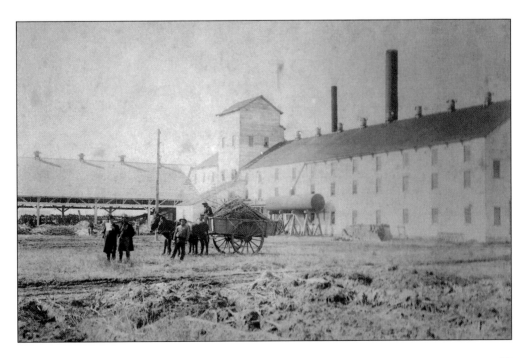

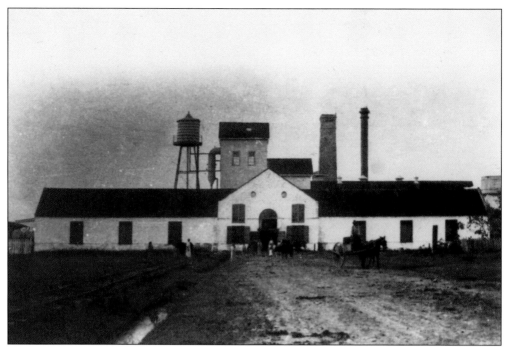

Claude Joseph Dubreuil Jr. purchased what is today known as Vacherie-Gheens from the Ouacha and Chaouacha Indians in the 1740s for 12 head of cattle. He established a cattle ranch, or "La Vacherie," as it came to be known, in order to furnish the New Orleans markets and the Louisiana colony with beef. In 1879, John R. Gheens of Kentucky purchased a portion of the Dubreuil holdings. In 1890, Gheens and his brothers incorporated the Golden Ranche Sugar & Cattle Company.

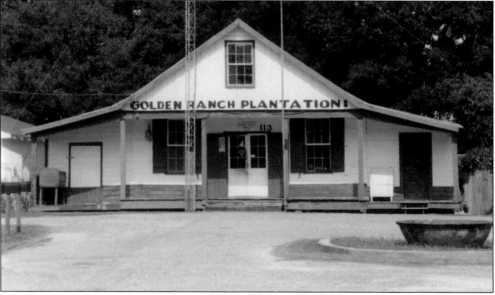

A plantation store that sold general merchandise and other plantation supplies was established on the plantation in the 1880s. The store also housed the Gheens Post Office, which was established in 1886. Both the store and the post office remained in operation for over 100 years.

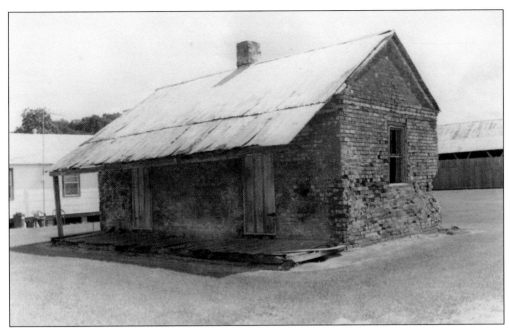

In 1828, Charles Derbigny and Noel LeBreton purchased a portion of "La Vacherie" to establish a sugar plantation. They built a brick sugar mill, 12 brick slave cabins, and many other plantation buildings. Sections of the original sugar mill and one slave cabin (above) still exist. It is the only surviving brick slave cabin in Lafourche parish. The mill ceased operations in 1925. The main house (below), known as the "Big House," was remodeled extensively in the 1960s.

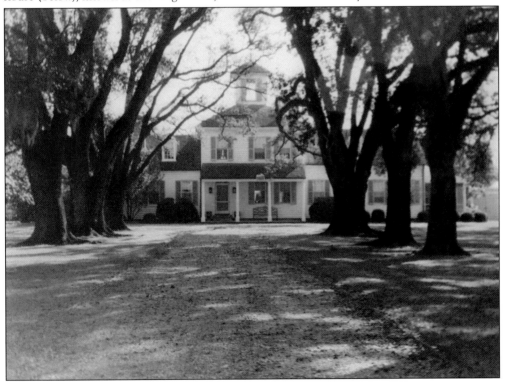

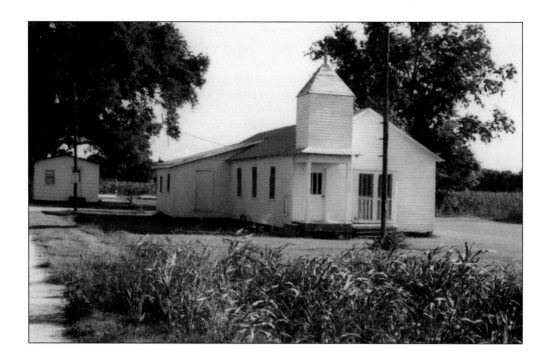

The Sunlight Baptist Church and Cemetery are located on the Golden Ranch Plantation. The church congregation dates to the 1800s. Early baptisms, as seen below, were held in the Company Canal, located near the church. Although the church and cemetery still exist, the congregation worships at a new building in Raceland known as the New Sunlight Baptist Church. (Below, courtesy of Kathryn Daigle Babin.)

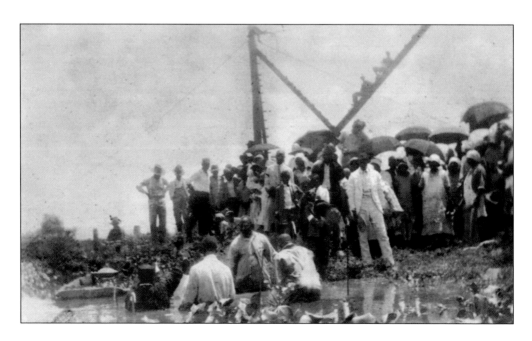

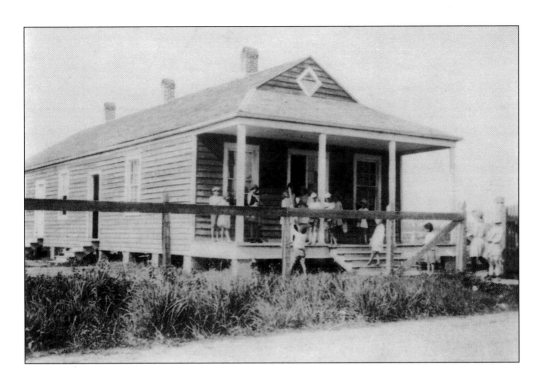

There were two schools in the Vacherie-Gheens community. One was located in the Vacherie community near the Catholic church, and the other was located on the Golden Ranch Plantation at Gheens. Grades one through seven were taught at the Gheens school, shown below. The school building at Gheens, constructed in 1923, replaced an earlier structure built in 1897. (Above, courtesy of Melva D. Cressionie.)

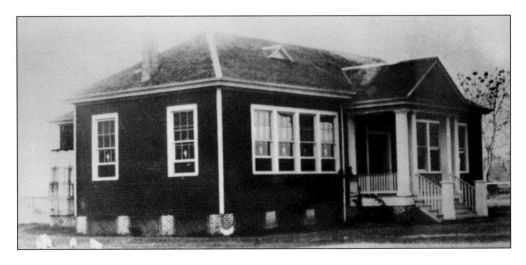

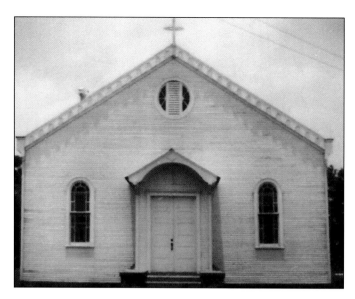

The original St. Anthony Catholic Chapel, in the Vacherie-Gheens community, was built in 1896 by Father Eugene A. Vigroux as a mission of Holy Savior Church in Lockport. In the early 1900s, this chapel was destroyed in a storm. It was replaced by a new chapel built around 1933. This chapel was later destroyed by Hurricane Betsy in 1965, shortly after the author's parents were married there. (Courtesy of Kevin Allemand, Diocese Archives.)

The small chapel pictured here was built on the Golden Ranch Plantation in Gheens. Although the date of its construction is uncertain, it is thought to date to 1915. This chapel served the Catholic congregation after the Vacherie Chapel was destroyed, and it is believed that its use was discontinued after vandals desecrated the altar. The building was finally dismantled in the 1960s. (Courtesy of Elsie P. Matherne.)

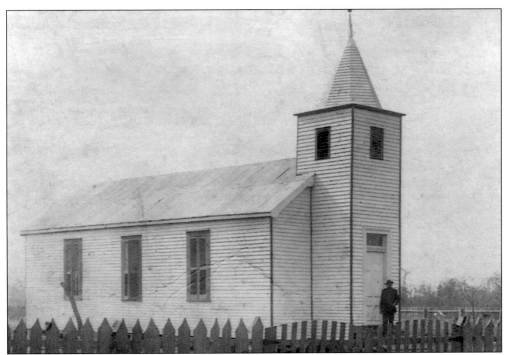

The Gheens Presbyterian Church was established on January 29, 1915, with 26 charter members. The construction of the church began later that year; however, it had to be rebuilt after the hurricane of September 29, 1915. The first services were held in French, the predominant language of the congregation, and also in English. The church and cemetery are located next to the Company Canal on Golden Ranch Plantation. (Courtesy of Kathryn Daigle Babin.)

Lockport was originally known as Longueville when it was established in the early 1800s. In the 1830s, William Fields donated land for the site of canal to create a direct route from Bayou Terrebonne across the lakes and Bayou Lafourche to New Orleans. The canal was built by the Barataria & Lafourche Canal Company. Today, the canal is known as the Company Canal. After the locks were built in 1850, the name of the town was changed to Lockport. (Courtesy of Bayou Lafourche Folklife Museum.)

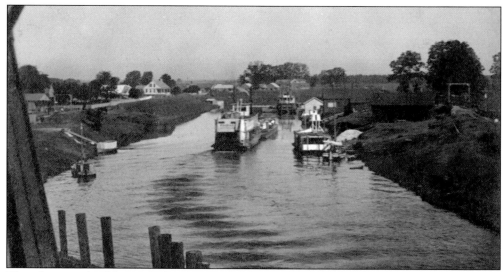

This photograph of Bayou Lafourche was taken at Lockport, with a view looking north at its juncture with the Company Canal. The frames of the two original wooden bridges that crossed the canal are pictured on either side of the bayou, parallel to each other. The large white house is the Mayet home, and the home in the distance near the trees is the Bourgeois residence, which was demolished in 1938.

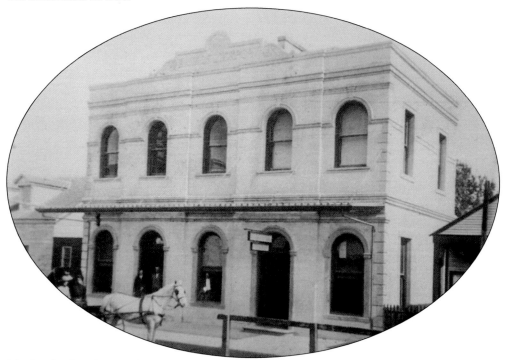

The Bank of Lockport, which opened in 1901, is located on Barataria Street. The original bank building was one story, and it was later enlarged with the addition of a second story. Its president was Eugene Constantin, and Dr. A.J. Price served as vice president. The cashier was Elson A. Delaune. The building also housed the post office until the 1940s. (Courtesy of Paul Chiquet, South Lafourche Public Library.)

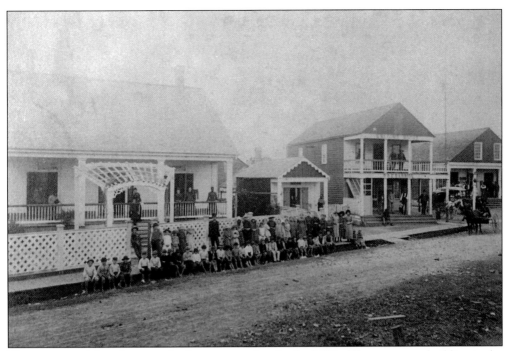

This scene on Main Street in Lockport was taken in the 1890s. The two-story building is the Welcome House Hotel, located on the corner of Main and Lafourche Streets. (Courtesy of Bayou Lafourche Folklife Museum.)

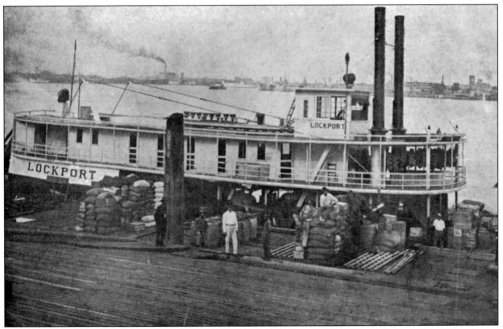

The Barker Barge Line operated a fleet of freight barges and two steamboats named *Lockport* and *Climax*. The company, which was owned by Capt. Alex Barker, delivered freight from New Orleans to landings at Lockport, Raceland, Lafourche Crossing, and Thibodaux. Barker also owned a boatbuilding and repair business.

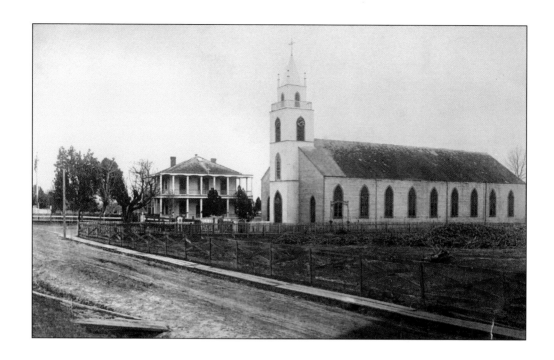

Holy Savior Catholic Church, in Lockport, was established in 1850 and was originally known as St. Andre's. The small wooden chapel used in the 1850s was replaced in 1870 by a church dedicated to the Holy Savior, which is shown above. This church was destroyed by a hurricane in 1915. The third church, pictured below, was constructed shortly thereafter and served the parish until the present church was built in the 1950s. (Both, courtesy of Kevin Allemand, Diocese Archives.)

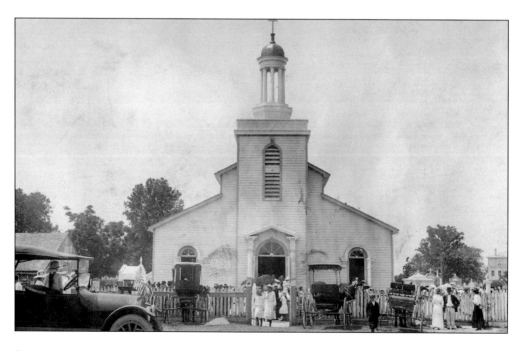

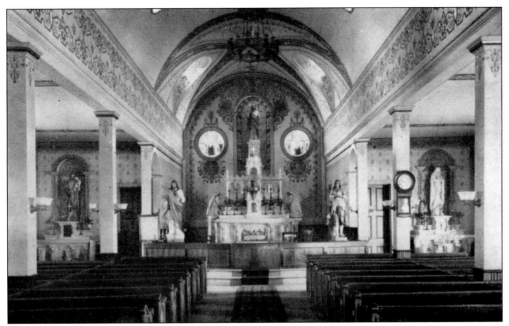

This interior photograph of the third church building in Lockport shows the elaborate hand-painted and stenciled walls. This work was done by Father Yves Grall, who lived in Lockport from 1915 to 1918. He, along with an assistant, painted the interior with bright colors and applied pure gold leaf to certain areas. (Courtesy of Kevin Allemand, Diocese Archives.)

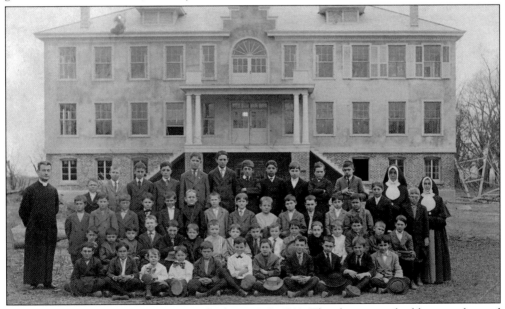

Holy Savior School and Convent was built in 1910–1911. The three-story building was located just behind the church and cemetery. The third floor of the building was used as the convent, and the two lower floors housed classrooms and an auditorium. The first graduation ceremony took place in 1918. The building was demolished in 1966 after being damaged by Hurricane Betsy the previous year. This photograph was taken shortly before the building was completed. (Courtesy of Bayou Lafourche Folklife Museum.)

The Lockport Dance Pavilion was an open-air pavilion located on the bayou side of Main Street and was known for its Sunday night Jitney Dances, at which a fee of 5¢ per dance was charged. The pavilion was also used for other social activities. The building was later replaced by the American Legion Hall. (Courtesy of Bayou Lafourche Folklife Museum.)

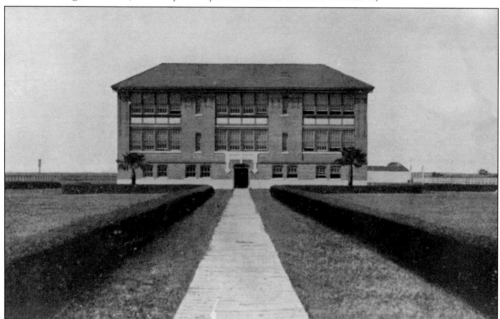

Lockport High School, a three-story brick building, was constructed around 1913 and housed grades one through eleven. The school was built after taxes were passed to fund three high schools for the parish, at Thibodaux, Raceland, and Lockport. The school was destroyed by fire in the winter of 1943. After the fire, some of the Lockport students were taught in different buildings while others were sent to various schools in the area. (Courtesy of Bayou Lafourche Folklife Museum.)

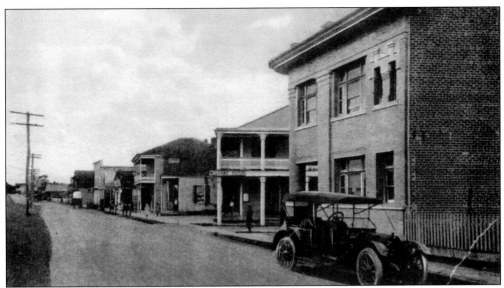

This view of Main Street looking south shows the Merchants & Planters Bank, the Welcome Hotel, and the Saia and Rossi Buildings. The bank, which operated from 1910 to 1913, was located on the corner of Lafourche and Main Streets. The building now serves as the Bayou Lafourche Folklife and Heritage Museum. After the bank closed, the building was used by Cumberland Telephone, Lockport Light & Power, and Louisiana Power & Light. (Courtesy of Bayou Lafourche Folklife Museum.)

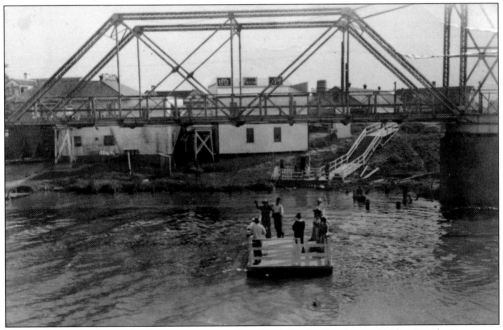

The first iron bridge at Lockport was erected in 1899 by the Lockport Bridge Stock Company. The bridge was owned and operated by Eugene Constantin, O.A. Bourg, and Jules Bregard. The company charged a toll of 5¢ to cross the bridge. Note the ferry crossing beneath the bridge, which led to the community of Rita. The second floor of the Constantin home can be seen to the extreme left. (Courtesy of Bayou Lafourche Folklife Museum.)

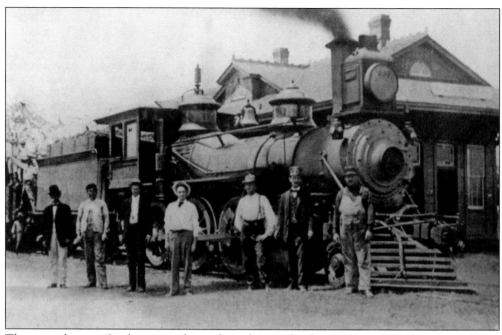

The train depot at Lockport was located on the east bank, near Rita. The depot served as a branch line for the Southern Pacific Railroad, formerly Morgan's Louisiana & Texas Railroad, which opened in 1905. (Courtesy of Bayou Lafourche Folklife Museum.)

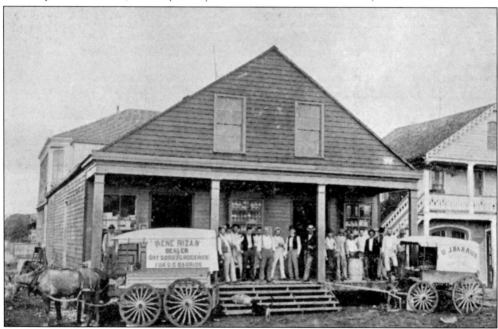

The Barrios Mercantile Company was located on the corner of Main and Lafourche Streets and was one of the largest mercantile establishments in Lockport. The president of the company was P.F. Meyer, the son-in-law of owner G.D. Barrios. The peddling wagons in front of the store belonged to Ulysses J. Barrios, who owned the Jewel General Merchandise Store, and Rene P. Rizan, who operated the Barrios wagon. The Lockport firehouse is on the right.

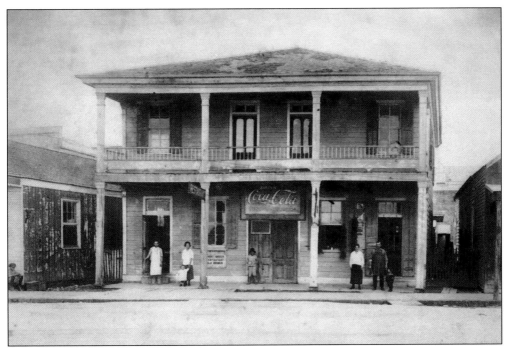

The Angelo Saia Building stood on Main Street between Barataria and Lafourche Streets. Saia was a shoemaker whose shop was on the first floor to the right. His family lived upstairs. The left side of the building served as a restaurant operated by the Mayet family. (Courtesy of Bayou Lafourche Folklife Museum.)

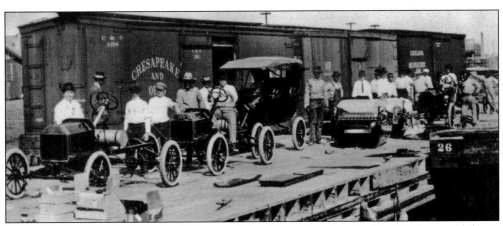

This 1916 photograph shows the Waguespack brothers unloading the first Ford automobiles in Lockport. Note that the cars were shipped unassembled and had to be put together upon arrival. The Waguespacks operated a store across the bayou from Lockport in Rita. (Courtesy of Bayou Lafourche Folklife Museum.)

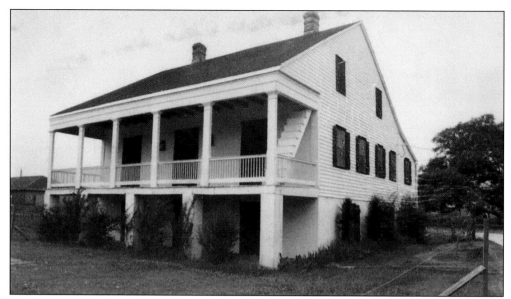

Bouverans Plantation Home was constructed shortly before the Civil War and is located south of Lockport along Highway 1. In 1860, Joseph Claudet purchased the property from Augustin Cunio. The plantation was named for the Claudet family's ancestral hometown of Bouverans, France. Other early sources refer to the plantation as Arialo. The house features both Creole and Greek Revival architecture. The Claudet family still owns the home today.

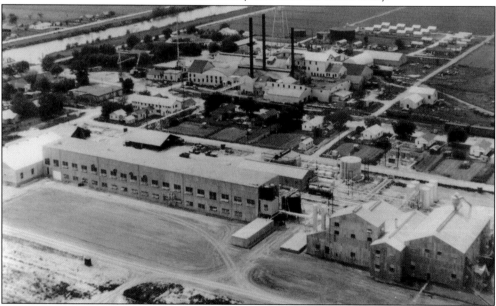

This aerial view of Valentine Sugars and Paper Mill was taken around 1960. The paper mill, constructed in 1953, can be seen in the foreground, and the sugar mill is in the background. In 1946–1947, the owners of Valentine Sugars worked with researchers to manufacture paper using bagasse, the waste material left over from the sugarcane stalk. The mill continued to use bagasse as a fiber source until the early 1980s, after which it used virgin and secondary wood pulp. The mill went through several owners before finally closing in 2007. (Courtesy of Bayou Lafourche Folklife Museum.)

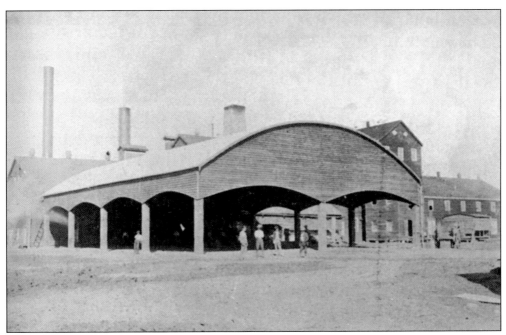

Valentine Plantation was originally known as Orange Grove. It was renamed Valentine after the wife of Joseph T. Badeaux, who owned the plantation in the late 1800s. Valentine was born in Thibodaux on Valentine's Day in 1850. Badeaux also owned Edna, Norah, and Eliska Plantations, all located nearby. He sold the Valentine Central Factory to the Lower Lafourche Planting & Manufacturing Company around 1907 and moved from the home seen below to a new home in Lockport. The plantation was later owned by the Foret, Jay, Barker, and Gibbens families. The photograph above shows the sugar mill around 1900. Valentine was the site of a German prisoner-of-war camp during World War II. During the war, the prisoners were used to help harvest the sugarcane crop at Valentine and other nearby plantations. (Below, courtesy of Dr. W.L. Simpson.)

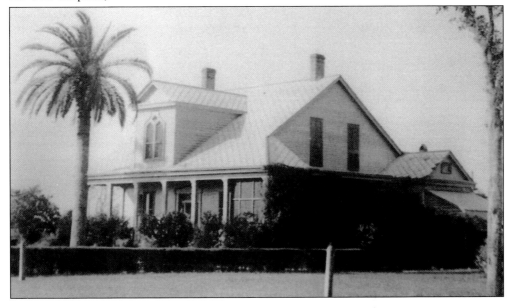

The Israelite Baptist Church was established at Valentine in 1920. It is known as the "Little Church in the Cane Field" because, from the main highway, it appears to be completely surrounded by sugarcane. However, it is accessible from a side road. John Barnes Jr. was a longtime deacon and choir member of the church.

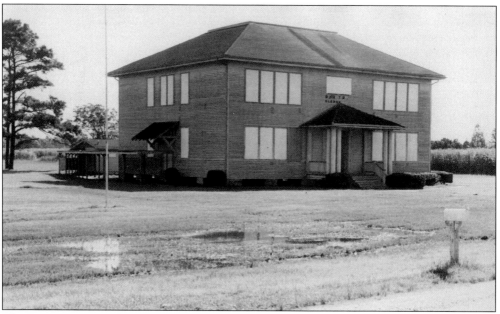

The District No. 7 School, constructed around 1919, consolidated two smaller schools known as the Ludevine School and the Marcelin Parr School. It was located on the east bank of Bayou Lafourche and served the area between Valentine and Rita. It housed grades one through seven. After Lockport High School burned in 1943, the school was used as a temporary school for the displaced upper-elementary grades.

Four

SOUTH LAFOURCHE
LAROSE, CUT OFF, GALLIANO, GOLDEN MEADOW, AND LEEVILLE

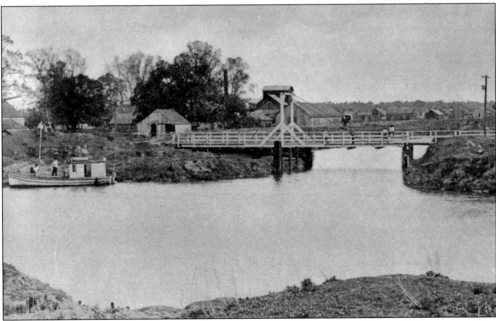

Pictured here is an early wooden bridge crossing Canal Harang in Larose. The surrounding community, originally known as Canal Harang, was named for Octave Harang. Later, the community was renamed Larose, after Felicien Larose, a local druggist who operated a drugstore and established the first post office for the area. The Gulf Intracoastal Waterway would later replace the old canal.

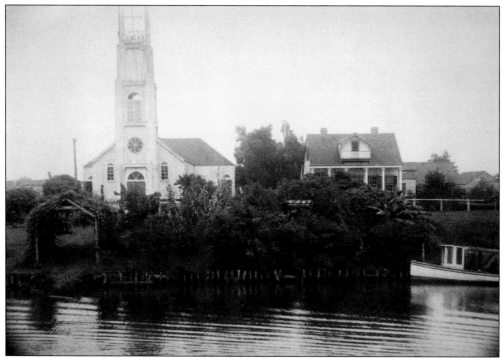

Our Lady of the Holy Rosary Catholic Church was established in 1873 at the juncture of Canal Harang and Bayou Lafourche, on property donated by Octave Harang. It was the first church parish created for southern Lafourche and would administer several missions for the area. The second church building, seen here, was replaced by the present church in 1933. (Courtesy of Paul Chiquet, South Lafourche Public Library.)

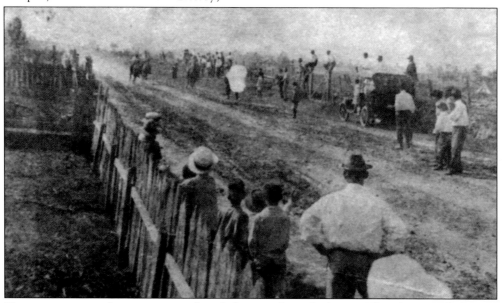

Horse racing was a favorite pastime for inhabitants along the bayou. This photograph shows a horse race after church on Sunday in Larose around 1915. (Courtesy of Paul Chiquet, South Lafourche Public Library.)

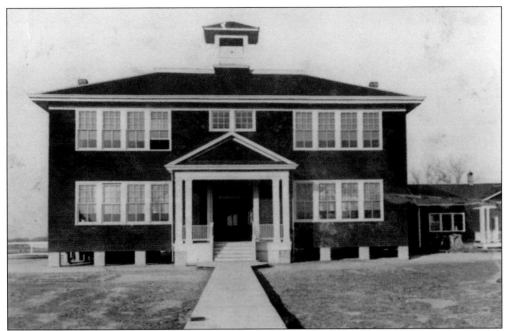

Larose High School was built in 1914. It was the fourth consolidated school to be built in the parish, after Thibodaux, Raceland, and Lockport. Two smaller schools, the Ledet and Larose Schools, were closed, and their students were transferred to the new high school. The building was located on the east bank of the bayou, just north of the juncture of Bayou Lafourche and the Intracoastal Waterway.

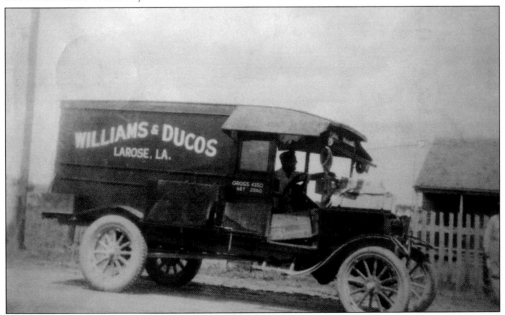

In addition to general merchandise stores, local merchants used peddling wagons or carts, as well as boats, to sell their wares to local residents. As times progressed, motorized vehicles became the means of transporting goods and supplies. These "rolling stores" traveled throughout the parish. (Courtesy of Paul Chiquet, South Lafourche Public Library.)

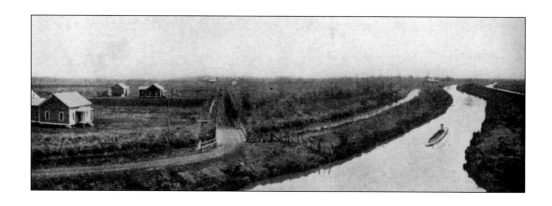

Delta Farms was one of several land reclamation projects begun in the early 1900s as a way to cultivate former marshland. In addition to Larose, projects were started in Raceland, Lockport, and Cut Off. The Larose project was located near the old Harang Canal, now the Intracoastal Waterway. A system of canals was dug for drainage, and the excavated material was used to build levees. The photograph above is an early view of Delta Farms, showing some of the farmhouses and canals. To advertise Delta Farms, as well as the other reclamation projects, the owners produced and distributed promotional booklets that showed the production yields of the property. The photograph below shows a group of visitors or potential farmers from the north. The property flooded when the levees failed in 1961 and again in 1971, after which the land was allowed to return to marshland.

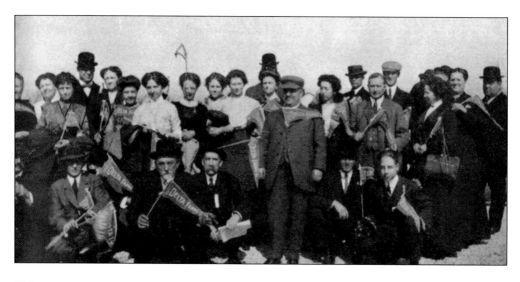

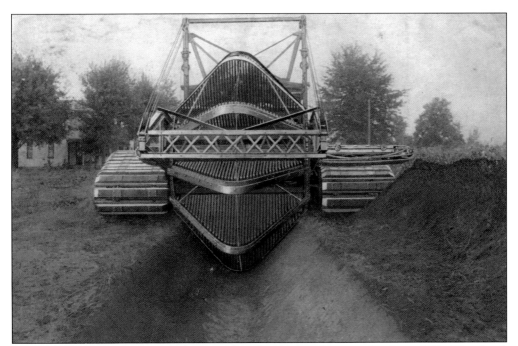

Seen here is the Hill ditching machine, produced in Ohio and invented by James Hill of Raceland, formerly of Ohio. This was one of 25 inventions Hill designed to drain and farm reclaimed land. The treads were necessary to prevent the machine from sinking into the soft marsh soil.

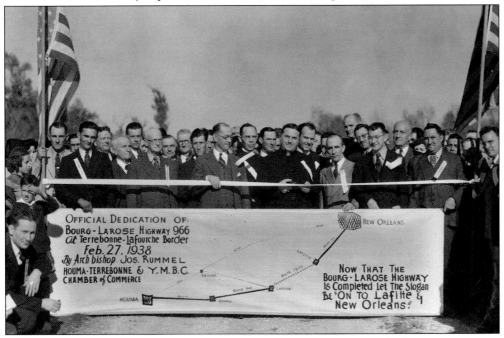

The Bourg-Larose Highway was officially dedicated in 1938, with several officials representing both Lafourche and Terrebonne Parishes. Although never completed, the original plans included a route from Larose to Lafitte that would offer a direct route to New Orleans. (Courtesy of Louella Picciola Pitre.)

Lee Brothers Dance Hall was purchased by Cleophas Lee from Jean Pitre in the late 1920s. The dance hall was moved by barge to its present location and remodeled and enlarged around 1941. (Courtesy of Paul Chiquet, South Lafourche Public Library.)

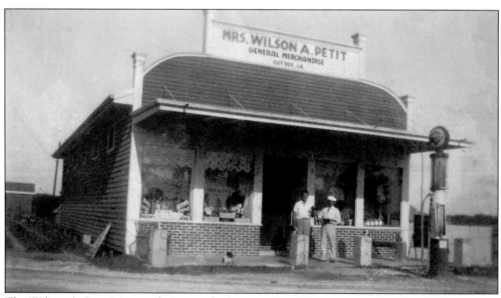

The Wilson A. Petit Mercantile Store, which opened in 1911, was located in Cut Off. It replaced the Julien Lefort store, which burned the same year. After the death of Petit in 1928, his wife, Lydia Lonibos Petit, ran the store under the name of Mrs. Wilson A. Petit. The store finally closed around 1943.

Sacred Heart Catholic Church was established as a mission in 1899 to minister to the settlers who relocated there after the 1893 Chênière Caminada hurricane. The congregation of Côte Blanche erected a chapel in 1899 that was later enlarged and repaired in 1909 after suffering hurricane damage. The cemetery at Sacred Heart was established after the yellow fever epidemic in 1905, and the church parish was dedicated in 1924. (Courtesy of Paul Chiquet, South Lafourche Public Library.)

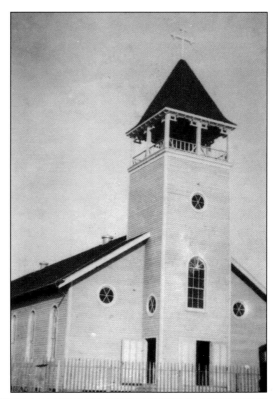

The Curole House was originally built along the coast at Chênière Caminada by Nicholas Curole in 1893. The Chênière Caminada community was destroyed by a powerful hurricane on October 1, 1893. Although it was heavily damaged, the Curole family salvaged their home and reconstructed it farther north along the bayou. The new community was known as Côte Blanche because of the number of painted white houses located there.

The Ducos House is located next to the Cut Off Canal, for which the community was named. The house sits atop a mound that was formed when the canal was dug in the 1850s. The canal served as a flood control outlet and provided a shorter route to New Orleans from Bayou Lafourche. The house was constructed around 1904 by merchant Elie Ducos. This structure was built in front of an older house that became the kitchen and dining room for the new home. Ducos died in 1909, shortly after the home was built. His wife continued to live in the house and ran the Ducos General Store until her death in 1938. The Ducos home remained in the Ducos family until 1992. The photograph below shows the store and service station, as well as the bank next door. (Both, courtesy of Bayou Lafourche Folklife Museum.)

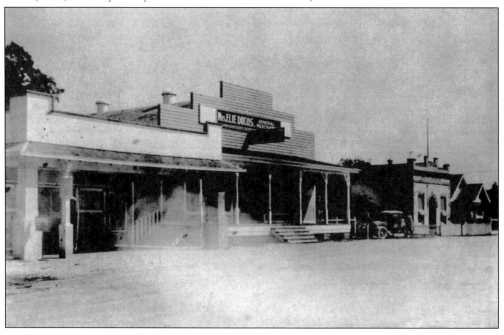

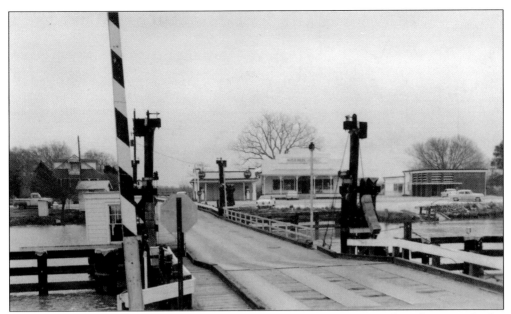

The bridge at Cut Off was originally built by merchant Elie Ducos. The toll on the Ducos Bridge was 5¢ to cross on foot and 10¢ to cross in a vehicle. The pontoon bridge seen here later replaced Ducos's old wooden bridge. The Ducos home and store were located just across the bridge on Highway 308. (Courtesy of Billy J. Pitre.)

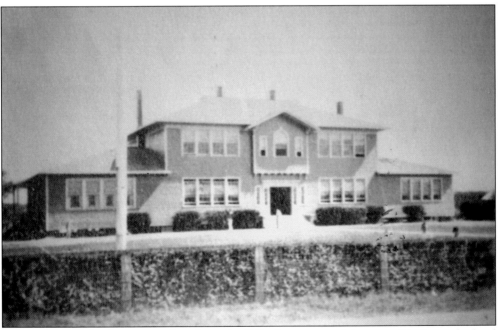

Cut Off High School was opened in the early 1920s. It was part of the consolidation and school building project initiated by the parish school board in 1918 and 1919. Cut Off School was located on the east bank of the bayou along Highway 308. The school consolidated the Elie Ducos School and the Lefort School. The two side wings were added at a later date. (Courtesy of Paul Chiquet, South Lafourche Public Library.)

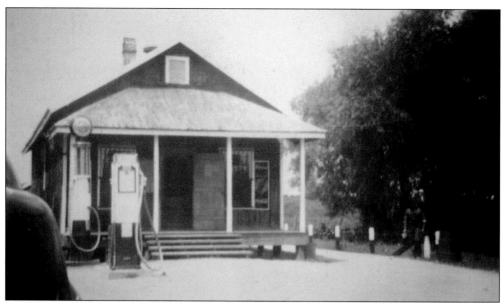

Clovelly Farms is located near Cut Off and is accessed by the Clovelly Road, or East Thirty-sixth Street, along the Scully Canal. Clovelly was a land reclamation project that began when Frederick Scully purchased the property in 1909. The 2,500 acres of marshland had to be drained and prepared before it could be farmed. Canals were dug in 1915, but the property was not cultivated until 1917. Due to the high acidity of the soil, the property had to continually be conditioned with sand to make it profitable. Sugarcane, potatoes, and corn were grown on the farm. Clovelly had its own general store, pictured above, as well as a school. The vehicle below was used as a school bus on Clovelly. (Above, courtesy of Paul Chiquet, South Lafourche Public Library; below, courtesy of Martin L. Cortez.)

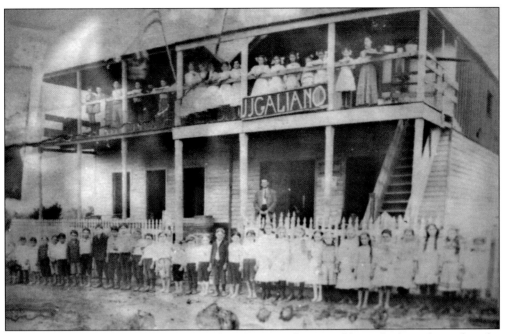

This photograph from around 1910 shows the Julian J. Galliano Building, which was located on the east bank of Bayou Lafourche in Galliano. The building housed a general store on the first floor and a school and barbershop on the second. Julian, seen standing on the porch, was the son of Salvador, the founder of Galliano. (Courtesy of Paul Chiquet, South Lafourche Public Library.)

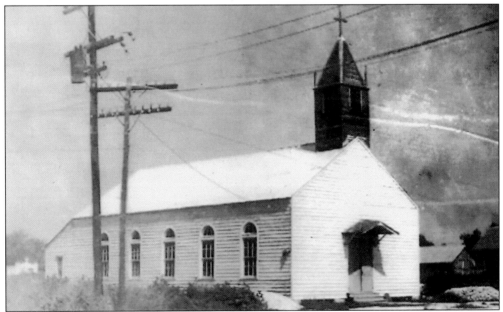

St. Joseph Catholic Church, in Galliano, began as a mission chapel of Holy Rosary Church in Larose in 1889. It was known as St. Jacob and was constructed of wood covered with palmettos. A frame church was built in 1903 and dedicated to St. Joseph. This building served the congregation until it was replaced in 1949. The parish was not established until 1958. (Courtesy of Paul Chiquet, South Lafourche Public Library.)

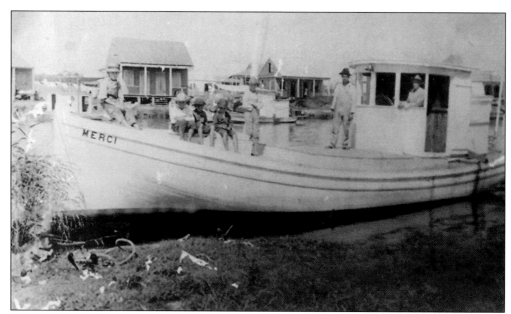

Southern Lafourche Parish is well known for its fishing industry, which includes crabs, shrimp, and oysters. Many of the residents in this area of the parish worked solely in the fishing industry until the discovery of oil and gas in the 1930s. Afterwards, many of the fishermen became employed by oil companies. The photograph above shows an early fishing vessel docked in Galliano. Many of the early sailing boats, or luggers, became motorized in the early 1900s. The photograph below was taken at one of the local seafood docks and shows a catch of shrimp and crab covered with ice. Note the bushel of crab on the left covered with Spanish moss, which helped keep the ice-covered seafood cold. (Both, courtesy of Paul Chiquet, South Lafourche Public Library.)

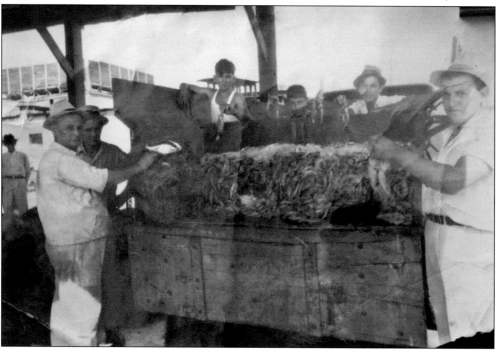

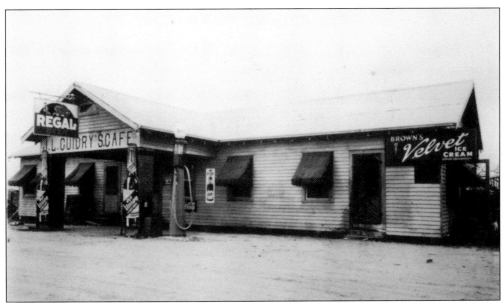

John L. Guidry and Lillian Lefort Guidry purchased property in Galliano, on the east bank of the bayou, in 1925. They opened a general merchandise store and later built several rental houses, an appliance and furniture store, an ice cream parlor, a saloon, and a theater. In addition, Guidry built a floating general merchandise store that he used to travel to remote areas where trappers lived during the winter. The rental houses were used heavily by local oil field workers. The building pictured above was used as a saloon, café, and ice cream parlor. The saloon featured a bar, slot machines, pool tables, and rooms for card games such as *bourré*, pedro, and poker. Guidry also built a ferry so that his customers on the west bank could access his store. John Guidry is pictured below dressed all in white.

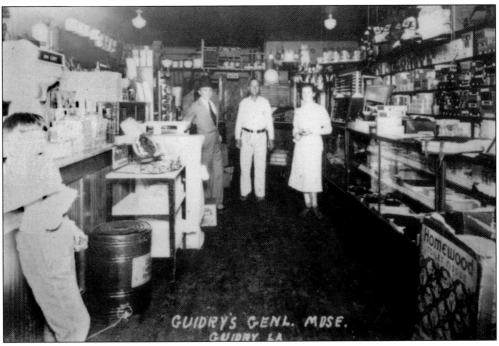

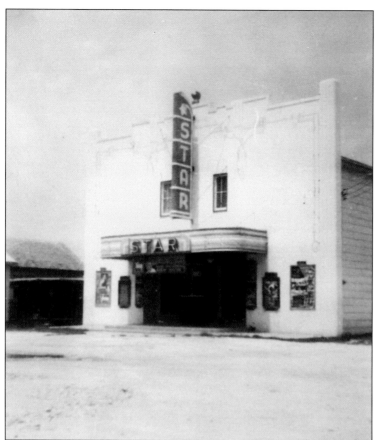

The Star Theater, in Galliano, was built in 1938 by the Black Gold Theater Company, Inc., which included John L. Guidry, Menton Chouest Sr., Dr. John Andre Gravois, Lefry Eymard, Ludwig Doucet, and Leo Theriot, who served as the bookkeeper. Eventually, Guidry and Chouest bought out the others' shares. The owners also provided bus service to and from the theater.

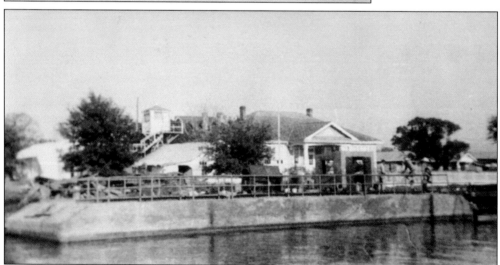

This photograph shows the old civil defense tower above the John L. Guidry Store, Galliano Elementary School, and the pontoon bridge. Galliano Elementary School was built after the parish school board purchased additional land from John L. and Lillian Guidry in 1938. After the school was opened, the Guidrys provided housing for the school's teachers. (Courtesy of Paul Chiquet, South Lafourche Public Library.)

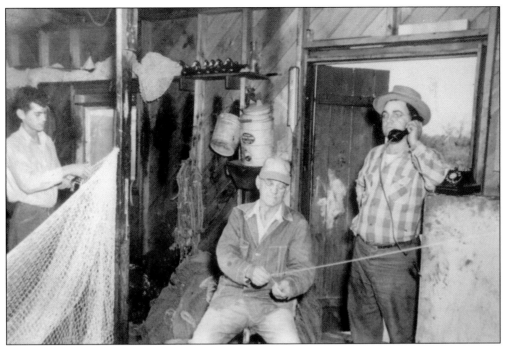

This net shop was one of many located in the southern part of the parish. Seining and trawling nets were all handmade by skilled craftsmen. Pictured here are, from left to right, Henry Pèrez, Alcindor Lorraine, and Alzac Terrebonne. (Courtesy of Paul Chiquet, South Lafourche Public Library.)

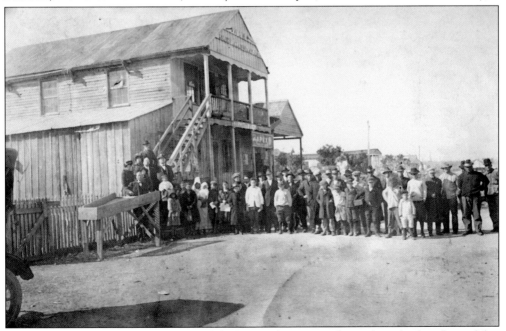

The Ernest Falgout grocery store, established around 1906, was located on the first floor of this two-story building. This is believed to be the first grocery store in Golden Meadow. The second floor was used as the Woodmen of the World Hall and later served as the first school. (Courtesy of Louella Picciola Pitre.)

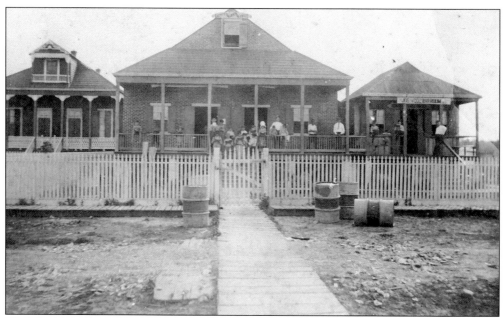

The Mrs. Marco Picciola & Son Store opened in 1912 after the family relocated to Golden Meadow from Leeville. The lumber salvaged from their Leeville store was used to build the new store. The photograph above was taken in 1915 and shows the Picciola home, to the left of the store, and the barroom of Joseph Nicol, on the right. After his grandmother's death in 1931, Marco II purchased shares of the business from his mother and brother and continued to operate the store until 1968. The building was torn down shortly afterwards. The post office was located next to this site for many years. Marco J. Picciola is pictured below with the store's peddling cart around 1917. This cart was used to sell meat from the store on a route that extended as far away as Cut Off. (Both, courtesy of Louella Picciola Pitre.)

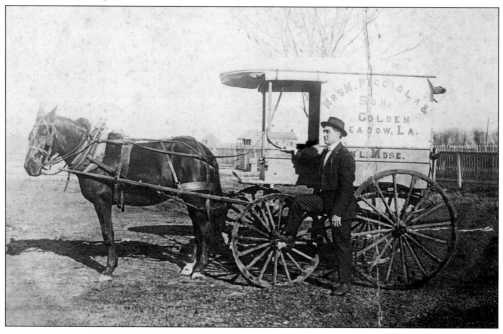

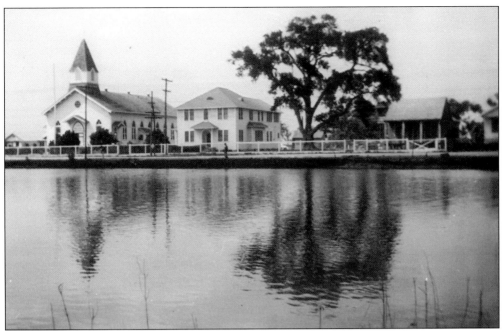

Our Lady of Prompt Succor, in Golden Meadow, was recognized as a mission of Holy Rosary Church, in Larose, in 1916. It was originally named St. Yves, after the patron saint of Father Yves Grall, who was first assigned to the mission. Services were held in homes and converted dance halls until a new church was built in 1922. This scene shows the church, rectory, and hall. (Courtesy of Paul Chiquet, South Lafourche Public Library.)

This is a 1939 scene of the annual Blessing of the Fleet in Golden Meadow. This tradition was begun in 1916 by Father Yves Grall, a native of Brittany, France, who used the same ritual practiced there for the French fishing fleet. The purpose of the blessing was to ask for protection and for a bountiful catch. The ceremony included prayers in the church, blessings for the fleet, and individual boat blessings with holy water. Refreshments were served afterwards in the churchyard. (Courtesy of Louella Picciola Pitre.)

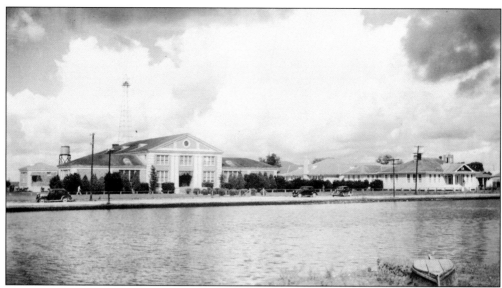

Golden Meadow High School was constructed in 1931 and was the first high school in the lower part of the parish. Before this school was built, students who wanted to attend high school had to travel to Cut Off or Larose. The school initially housed grades one through ten, but eventually taught through twelfth grade. The building now serves as Golden Meadow Junior High School.

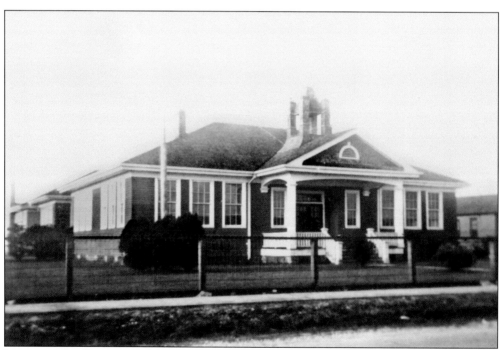

Increasing enrollment at Golden Meadow High School necessitated the construction of Golden Meadow Elementary School next door. The elementary grades were then transferred from the high school to the new building. Note the bell tower on the roof of the building. (Courtesy of Paul Chiquet, South Lafourche Public Library.)

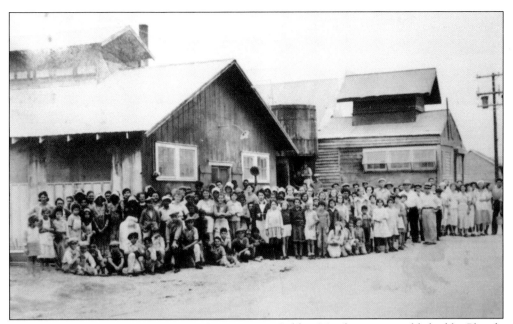

Morgan City Processing & Canning Company, in Golden Meadow, was established by Placide Bertoul Cheramie. It was one of several shrimp canning companies along the bayou. Cheramie initially opened a grocery store in the early 1920s, and then he opened the shrimp cannery in 1925. A large gathering of workers, many of whom are children, pose for this photograph outside of the canning company. (Courtesy of Paul Chiquet, South Lafourche Public Library.)

The brand of the Morgan City Canning Company, HO-MA, was printed on labels for its gallon-size cans, seen here. Pictured are Irene Terrebonne Kern, Early Trosclair (standing), and a state inspector named Mr. Babineaux. (Courtesy of Paul Chiquet, South Lafourche Public Library.)

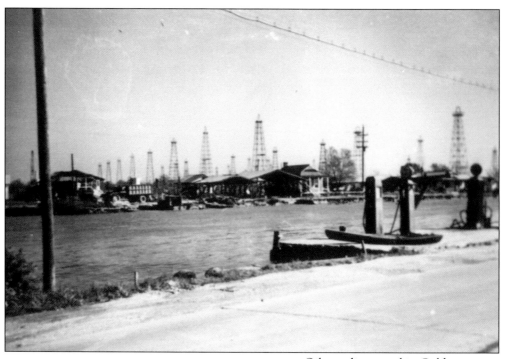

Oil was discovered in Golden Meadow in the late 1930s. Soon afterward, oil derricks were erected throughout the town, as evidenced by the photograph above. The small, unpaved streets of Golden Meadow were too soft for the heavy equipment and trucks that were needed to supply the derricks. The truck seen at left belonged to the L.E. Daviet Lumber Company, in Larose, and carried mud and cement needed for drilling operations. At the time, all mud and cement was purchased from local lumber companies. (Above, courtesy of Paul Chiquet, South Lafourche Public Library; left, courtesy of Offshore Oil and Gas History Project.)

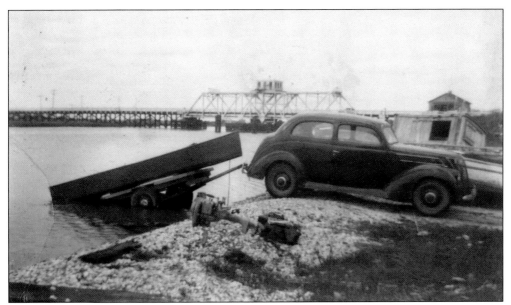

The first Leeville bridge was erected in 1908 and connected the communities of Leeville to Missville, located on the eastern bank of the bayou. This photograph shows the metal bridge that replaced the first wooden bridge. The boat launch was one of several launches located in the community. (Courtesy of Paul Chiquet, South Lafourche Public Library.)

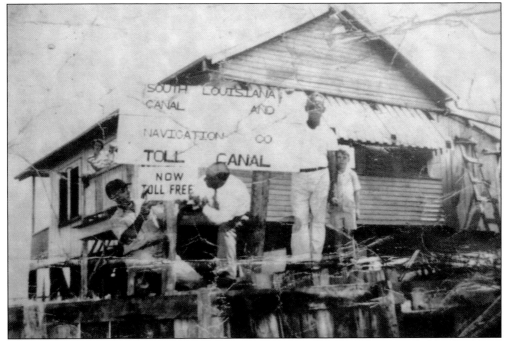

The South Louisiana Canal & Navigation Company operated a toll canal in Leeville as a means of traveling from Bayou Terrebonne to Bayou Lafourche and then on to New Orleans. The canal is known as the Sanders, or East-West, Canal. Here, Hick Cheramie and his son watch state officials place a "toll free" sign on the canal. (Courtesy of Paul Chiquet, South Lafourche Public Library.)

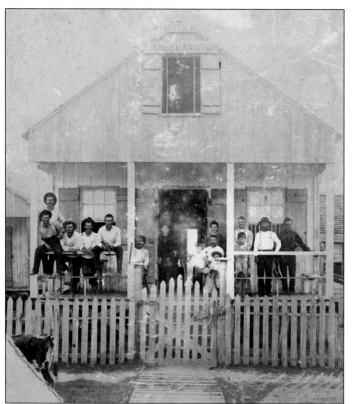

After the destruction caused by the 1893 hurricane at Chênière Caminada, Marco Picciola moved his store to Leeville and named it the Picciola Fisherman Store. After his death in 1895, his widow and their son Joseph ran the business. Pictured are Leo Lafont, leaning on the left rail; Theresa Picciola, in the doorway; Joseph, his wife, Josephine, and their two sons, Marco and Harris, to the right of the doorway; and Ernest Lefort and Nicol Constransitch, standing on the right. (Courtesy of Louella Picciola Pitre.)

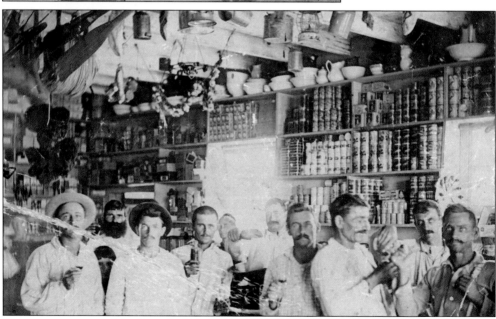

This interior scene of the Picciola Fisherman Store was taken before the yellow fever epidemic of 1905. Pictured, from left to right, are Pierre Collins, Nicol and Francis Constransitch, Octave Guilbeau, Exavier Malgum, Theresa and Joseph Picciola, John, Frank, and Octave and John Guilbeau. (Courtesy of Louella Picciola Pitre.)

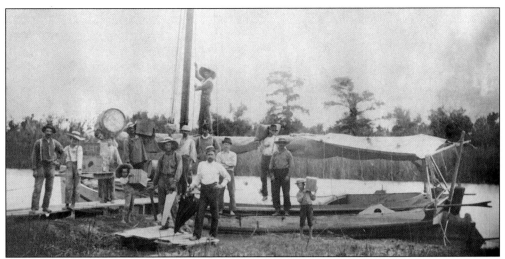

In the early 1900s, luggers were used to transport groceries and other supplies from New Orleans to homes and businesses along the bayou. Men unload groceries from the lugger seen here in front of the Picciola Fisherman Store, in Leeville, around 1900. The man in the foreground with the straw hat is Joseph C. Picciola. (Courtesy of Louella Picciola Pitre.)

The Leeville Cemetery was established in 1905, during the yellow fever epidemic. The land was purchased from the Martin family by the Leeville Cemetery Company, formed by Joseph C. Picciola, Camille Rebstock, and Adrien Lefort. Shortly after it was established, several members of the Lefort and Picciola families, including Joseph Picciola, were buried there. (Courtesy of Louella Picciola Pitre.)

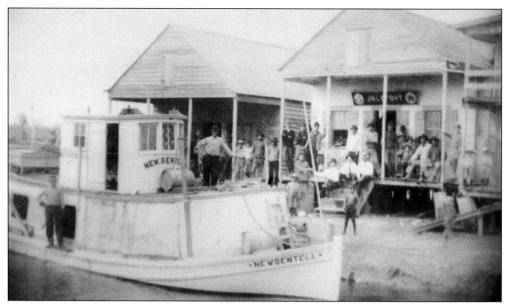

This 1905 photograph of Leeville shows the *New Sentell* cargo boat, which was used to deliver goods from New Orleans to Bayou Lafourche. The boat was owned by Michel Jambon. The buildings in the background are stores owned by Robert Martin and Julien Lefort, respectively. (Courtesy of Paul Chiquet, South Lafourche Public Library.)

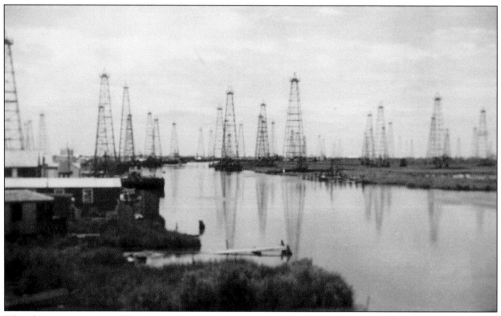

The destruction caused by several hurricanes in the early 1900s forced many of the residents to move farther inland to the communities of Golden Meadow, Galliano, and Cut Off. In the 1930s, the oil industry took hold in Leeville, which had numerous oil derricks. This photograph was taken from the old Leeville bridge in the late 1930s. (Courtesy of Paul Chiquet, South Lafourche Public Library.)

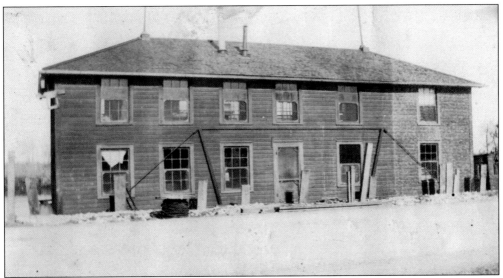

The oil industry brought in numerous oil field workers from outside of the parish, many of them from Texas. These workers were housed throughout the parish in hotels and other rental properties. One of the earliest to provide housing was Levy Collins, who rented rooms on his houseboat, seen here. This photograph was taken in Leeville near one of the first oil derricks. (Courtesy of Louella Picciola Pitre.)

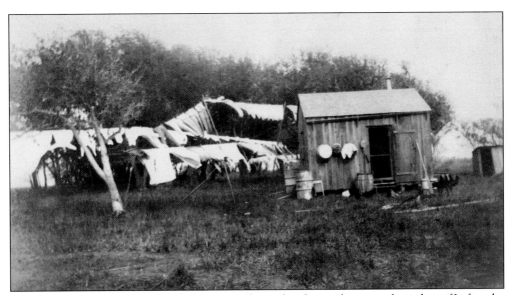

Chênière Perrilliat, sometimes called Perriac, is located at the southernmost boundary of Lafourche Parish, along the Gulf of Mexico between Port Fourchon and Chênière Caminada. This property, originally a land grant to the Dupre-Terrebonne family in the late 1700s, was sold to Joseph Perrilliat, the namesake of the chênière. The Michoud family and, later, the Plaisance family would also own the property. The cabin seen here was a typical trapper's cabin, which would have been a familiar site in the marshes of Lafourche. (Courtesy of Louella Picciola Pitre.)

Discover Thousands of Local History Books
Featuring Millions of Vintage Images

Arcadia Publishing, the leading local history publisher in the United States, is committed to making history accessible and meaningful through publishing books that celebrate and preserve the heritage of America's people and places.

Find more books like this at
www.arcadiapublishing.com

Search for your hometown history, your old stomping grounds, and even your favorite sports team.